RODIN ON ART

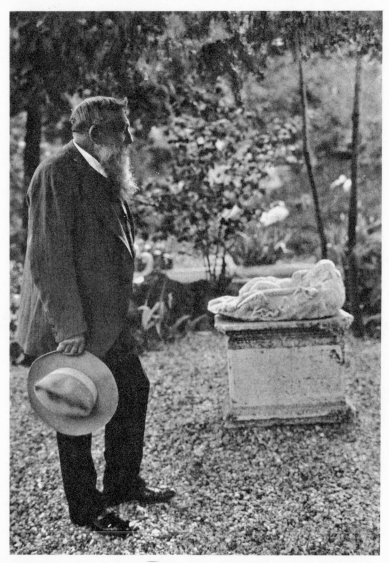

1. Rodin in his garden

RODIN ON ART

Translated from the French of
PAUL GSELL

by

MRS. ROMILLY FEDDEN

[Rodin, Auguste]

Introductory Essay

by

RICHARD HOWARD

Horizon Press New York

Plates 2, 5, 6, 7, 8, 11, 19, 25:
Philadelphia Museum of Art

Plates 29, 30, 32, 33, 34, 35, 36, 37, 38, 39:
Philadelphia Museum of Art,
given by Jules Mastbaum

FRAGMENTS OF A "RODIN"

for Emma Joseph, who provided

I

In March, 1970, an act of violence and vandalism was committed in Cleveland, Ohio, its victim a cast of Rodin's statue known as *The Thinker*: dynamite had been wedged between the grasping bronze toes, and sometime after midnight the figure was blown off its pedestal, the lower portion suffering considerable damage. Though put back in place, the statue itself has not been restored, and it looks—legs torn open, buttocks fused, the wonderful patina even more spectacular where the metal is gashed and split, a slender steel palisade boxing in the unbalanced torso—it looks like a "modern" statement now, something closer to a Reg Butler hominoid impaled on its thorns or a realization in the seething bronze of one of Francis Bacon's horrors, neatly jailed, keeping or kept at its distance, than to the celebrated figure created in 1879 and crouching, as we all know, before so many museums, colleges and courthouses across the country.

Growing up in Cleveland, I had seen this particular *Thinker* at work in front of our art museum—had seen it every week, sometimes every day, and inside the museum I had seen other statues I was told Rodin had made, particularly a pair of creamy marble clumps, *The Kiss* and *The Hand of God* (mod-

i

FRAGMENTS OF A "RODIN"

elled, Miss McFeelsy said, after the sculptor's own hand!) —
which appeared very different indeed, lapped so smooth the
light found nowhere to go but inward, from the rugosities of
the image we visiting schoolchildren entitled, with an alle-
gorical impulse quite as merciless as the Master's, *The Toilet.*
And when I read in the papers, even in *The New York Times,*
about the explosion of this childhood icon (by now I had seen
its consessioner before Philosophy Hall at Columbia Univer-
sity, and I had visited the Rodin Museum in Philadelphia and
even the Musée Rodin in Paris), I realized as surely as if I had
heard the nymphs crying "the great god Pan is dead" when
Christ was born, that an era was over, that a hinge had folded,
and that life, as Rilke said apropos of another broken statue,
must be changed.

Why, I wondered, had "they", nameless and faceless agents
of Darkness, done the deed at all? No slogans scrawled on the
pedestal indicated the provenance of such destruction, yet the
mischief was too intricate to be no more than some midwest
version of an *acte gratuit*—it lacked the adorable spontaneity
of the Absurd. At first I inclined to believe *The Thinker* had
been blasted because it was *thinking.* This was 1970, after all,
and anti-intellectualism is scarcely a minor tributary to the
stream of American life. But there was a ruinous paradox in
my reasoning—indeed, had I not already noticed that the
somewhat squashed effigy had a new pertinence, a deeper
significance? The wound merely enhanced the wonder of
thinking. The only way to overcome a thought is by...another
thought. And the only victory over *The Thinker* would be,
say, disposable earthworks or primary sculpture, some em-
blem of unthought—not the vandalization of a received
emblem of thought.

Then, recalling that the figure had been enthroned, origi-
nally, above the lintel of *The Gates of Hell* and that Rodin
intended it to be called *The Poet,* for it was to represent Dante
conceiving the tormented universe of forms which writhed
beneath him, I presumed that the same negating hostility to

ii

FRAGMENTS OF A "RODIN"

association, to history and to the very presentiment of the
past had functioned here as had dictated the cancellation of
the program-cover of the Republican Presidential Convention
in 1956, when Rodin's *Three Shades*—chosen by a committee
to illustrate Peace, Progress and Prosperity—were discovered
to be the guardians who point down into the same swirling
inferno over which *The Thinker* so creatively broods. Yet
most people have no notion that Rodin's most popular work
is not seen by them as he intended it to be seen—as part of an
encyclopedic, and unfinished, apocalypse; any more than they
realize that Rodin never touched a chisel, never "carved" all
those caramelized creations that came out of his *atelier* from
the hands of Italian artisans busily producing sentimental
marble facsimiles of what the master's hands had modelled
in clay, plaster and wax.

No, *The Thinker* had not been blown up because it was
thinking, or because it was thinking about Hell or history, or
because it would be fun to blow it up; *The Thinker*, I was
obliged to conclude, had been blown up because it was a spe-
cial kind of art, because it was by Rodin. What, then, had that
come to mean—"by Rodin"?

The answer might lie in a name-dropping still-life with a
title lifted from Kipling, who certainly belongs in the picture:
A sonata is only a sonata, but a cigar is a good smoke. Under
a framed lithograph of Brahms playing the piano and puffing
on a cheroot—a Brahms bearded like Whitman, like Ibsen, like
God and like Rodin himself (whose hand, I knew, already
partook of divinity)—there was a shelf of books in our house,
and the biggest book, with the same luxuriant margins, the
same gravure illustrations shielded by a wisp of tissue-paper,
the same *propos* of the Master gathered as in a chalice of
reverent *inquirendo* by Paul Gsell, was to be found in the
houses of all my parents' friends, if not under Brahms then
on top of the piano, among the folds of an art-scarf which
might have been snatched from Isadora's chubby shoulders.
This was the book republished now by Horizon Press, and on

iii

its spine were but two words, though they appeared in very large letters: ART, and beneath that, a trifle larger, RODIN.

For my family and their friends, for an aspiring middle-class America in the first four decades, say, of this century, the assumption was not that Rodin made art, but that Art was what Rodin made (as Poetry, for the preceding generation, had been what Tennyson wrote). Objects which came, or were said to come, from Rodin's hands were art because they were made by an artist (*cherchez l'homme* is the motto of the middle class), and they were great because they were made by a Great Artist—not because of their intrinsic qualities, formal properties, but because of a justifying aura of comment supplied by the Master. That is how the middle class has always recognized art: by the directives of the artist and his ape the critic. Only an aristocracy, of course, can afford to respond to such objects *unmediated;* even triumphant, the bourgeoisie never asks "is that what I like?" but only, anxiously, "what is it supposed to mean?" Rodin, among others, told us, and we believed, we recognized. This book is one of the places and ways in which he told us. But to determine an analogous recognition in the history of sculpture, to affix a *cachet* with the same complacent unanimity, we should have to look back as far as Canova, perhaps as far as Bernini—and that far back, no such recognition could be made by the middle classes, which were merely rising; by the time I was poring over ART by RODIN—or was it RODIN by ART?—they had risen.

Other books, as I mentioned, shared with Rodin that shelf which showed forth, until it showed up, the last word in middle-class taste, and though it appears to be period taste now (which means taste, period), who can afford to condescend to such choices when we consider our own last words? There were the works of Maeterlinck and Rostand and d'Annunzio and Anatole France (a long red row, the latter, from which I would learn, as again from Schnitzler, that *libertine* is a diminutive of liberty) ; there were the scores,

on the piano, of Puccini and Massenet (the "Meditation" from *Thaïs* was played at my mother's wedding!) ; and there were certain numinous figures, living persons whose appearances and performances (often, as in the case of the Divine Sarah, identical) had to be granted the same inviolable veneration with which certain books were to be read: Nijinsky, Caruso, Duse. . . Certainly, after the Great War there was a Great Snobbery about the other side of the Atlantic, a great craving for spoils. But more than any other creative figure—even more than Richard Strauss (music, after all, even music orchestrated by Strauss, could not be *owned* in the way marble and bronze and mere clay could be owned, as chthonic trophies)—Rodin satisfied that craving, fulfilled the needs of the class and circumstance in which I grew up—the class defined, abruptly, by the circumstance of having "been"—by which was meant having been to Europe. A class which is, today, a has-been, for it has been had—by its own possessions, despoiled by its own spoils, among which few were so proudly carted home as the statues of Auguste Rodin.

There were, of course, several Rodins. There was the Rodin who did—if indeed he did them—marble busts of Mrs. Potter Palmer and her friends for colossal sums; there was the Rodin who scandalized the townspeople of Calais by insisting that civic virtue and patriotic sacrifice were not always noble and exalted, that heroism is a form of solitude—a suffering form; there was the Rodin who questioned the very pride of the body he glorified, who in *The Old Courtesan* articulated with unendurable persistence the miscarriage of life, the futility of effort, the impotence of the mind, the weakness of the flesh; and there was the Rodin who, taking a big mouthful of water and spitting it onto the clay to keep it constantly pliable, did not always aim well and soaked George Bernard Shaw:

> At the end of the first fifteen minutes, he produced by the action of his thumb a bust so living that I would have taken it away with me to relieve the sculptor of any further work.

v

FRAGMENTS OF A "RODIN"

...But this phase vanished; within a month my bust passed successively, under my eyes, through all the stages of art's evolution. The careful reproduction of my features in their exact dimensions of life...went back mysteriously to the cradle of Christian art, and at this moment I had the desire to say again, stop and give me that. It is truly a Byzantine masterpiece. Then, little by little it seemed that Bernini intermingled with the work. Then, to my great horror, the bust softened in order to become a commendable eighteenth-century *morceau*, elegant enough to make one believe that Houdon had retouched a head by Canova....Once again, a century rolled by in a single night, and the bust became a bust by Rodin and it was the living reproduction of the head that reposes on my shoulders. It was a process that seemed to belong to the study of an embryologist and not to an artist.

With characteristic acuity Shaw hits on what appealed to Rodin's public—not only to his patrons who wanted to be flattered, consoled, immortalized, but to a vast audience which knew what art ought to be, though it may not have known what it liked: art was science ("the study of an embryologist"), not the genesis of a vision, not revelation but realism, but the reproduction of what we see with our own eyes. By this dispensation, art need not—always—reassure, but it must tell the truth, and that was what Rodin the evolutionary biologist claimed to do: "I am not a dreamer," he said, "but a scientist. . . There is no need to create. Genius comes only to those who know how to use their eyes and their intelligence."

This, even more than the indulger of duchesses, was the Rodin that was detonated on the steps of the Cleveland Museum of Art—the mediator of an eternal human nature (that pretext of capitalism), the mouthpiece of the bourgeois aesthetic which makes art an art of detail. Based on a quantitative representation of the universe, this aesthetic demands that the truth of any whole be no more than the sum of the individual truths which constitute it—as Rodin used to say that a statue was the sum of all its profiles. In consequence,

an emphatic significance is attributed to the greatest possible quantity of details, and the mimetic surface thus produced is one of literally sensational intensity. As Albert Elsen, Rodin's most scholarly critic, puts it:

> within an area confined to a few inches on the sculpture, each fingertip will encounter surface inflections of a different character; feeling one's own arm, one gains the impression that the surfaces conceived by Rodin are more richly complex.

It is an art which refuses to transform the world (choosing, as Elsen shrewdly suggests, to *enrich* it, to capitalize on our losses), which urges instead its obsessive record; indeed, an art which offers its hypertrophied mimetic surface not merely as an enrichment but as an homeopathy: to inoculate us with a contingent ill in order to forestall an essential one. This is what Roland Barthes calls the Essentialist Operation: to insinuate within an Order the complacent spectacle of its servitudes as a paradoxical but peremptory means of glorifying that Order. *The Age of Bronze, Eternal Spring, The Cathedral*—our middle-class *frisson* upon finding these "noble" titles affixed to works of a convulsive naturalism fades into acceptance, an acceptance of their ulterior and not their inherent function. To label *Dawn* (or *France* or even *Byzantine Princess*—it comes down, or climbs up, to the same) the semi-transparent wax mask of Camille Claudel, the poet's sister and the sculptor's mistress, may rid us of a prejudice about the individual human countenance, but it is a prejudice which cost us dear, too dear, which cost us too many scruples, too many rebellions, and too many solitudes. To call an image of human flesh *The Thinker* is an allegorical holding-action, an alibi which manifests initially the tyranny and the injustice of that flesh, the torments it endures, the reproaches it incurs, only to rescue it at the last moment, *despite* or rather *with* the heavy fatality of its complaints, by calling it so. *Saving the appearances* by sovereign appellation, that is the Rodin who buttered up Puvis de Chavannes and his wan

aristocratic allegories, that is the artist, and that the art, which passed — with its audience — from universal acclaim, from smug persuasion, in a flash of gunpowder. For it is written: I will show you fear in a handful of dust.

II

In the Print Room of the British Museum, if you have managed to murmur the proper words in the proper quarters, an attendant will set on the table before you any number of green buckram boxes, each large enough to contain an overcoat. Inside them, however, are not overcoats but the majority of the watercolors of Joseph Mallord William Turner, mounted though unframed, many with Ruskin's characteristic annotations ("nonsense picture") on the reverse—thousands and thousands of works, constituting one of the greatest achievements in art, though only a few of these pictures have been reproduced and a few more exhibited.

Here or in another such room, a deplorable scene occurred soon after the painter's death, at the age of 76, in 1851—a scene which nothing but the profusion and perfection of what is in these boxes can keep us from mourning as more than an incidental loss: according to W. M. Rossetti, Ruskin (who was not yet 35 at the time) found among these works several indecent drawings "which from the nature of their subjects it seemed undesirable to preserve", and burned them "on the authority of the Trustees" of the National Gallery. Rossetti had been helping Ruskin to sort the Turner bequest, and neither he, Ruskin, nor the Trustees were swayed by the fact that Turner evidently considered the sketches *desirable to preserve*. Nevertheless, we find in these green boxes many rapid drawings and watercolors, executed after the artist's fiftieth year, of naked lovers copulating, of naked girls embracing. According to Turner's biographer, the genitals in many sketches are plainly shown, even enlarged. These erotic works illustrated what Turner himself, in a verse writ-

ten much earlier, called "the critical moment no maid can
withstand/when a bird in the bush is worth two in the hand."
Apparently there were many more of these caprices than
the ones which survived the Rossetti/Ruskin sifting, but as
in the case of the great mass of the Turner watercolors, they
were not executed for sale or for exhibition—they were exe-
cuted for the artist's sole delectation. Turner was the first
major artist to show this division between a public and a pri-
vate art—between the astonishments of Varnishing Day and
the unvarnished truth of the studio.

In the archives of the Musée Rodin, there are about seven
thousand drawings and water-colors by the Master; no one
may see them, for as anyone knows who has attempted to
undertake research in that country, France is a bureaucracy
tempered by spitefulness, and though the canonical 50 years
since Rodin's death have passed, the work has not been made
accessible to students. About 200 drawings and water-colors
are exhibited in the museum, and there are perhaps as many
in other collections. Nothing, apparently, has been destroyed,
but we are in something of the same case as with Turner:
the world lies all before us, where to choose?

Like most of Turner's water-colors, like all of his later
ones, Rodin's were painted for himself; they are a private
art. So often accused of melodrama, of oratory, of sensation-
alism, both men, we must remember, created an entire *oeuvre*
apart in which nothing happens but in which nothing is kept
from happening—the art of the late Turner, of the late Rodin
(who first permitted a large group of his wash-drawing to
be exhibited in 1907, when he was 67), is the greatest example
with which I am familiar in the history of art of an art
without history, an articulation of a life that can be lived
without repression, without sublimation, in eternal delight,
in endless play, in the undifferentiated beatitude of bodies
and earth and water and light whose realm is eternity, not
history. The eroticism, even, of Rodin's and of Turner's pic-
tures has nothing to do with the drama of sex—it is the ecsta-

tics of a condition, not of an action, and when we label it polymorphous-perverse we mean merely that it is playful, exuberant, gay.

In considering the pleasant symmetries of the two artists: that each of them ended and began a century of taste; that each of them lived over three-quarters of a century without ever marrying, though entertaining intractable relations with an "unsuitable" woman; that each of them conducted two opposing careers, the first charged with virtuoso scandal —it was Hazlitt who as early as 1814 saw "a waste of morbid strength, visionary absurdities, affectation and refinement run mad" in Turner, and an organizer of the American National Sculpture Society (in 1925!) who saw in Rodin "a moral sot" and in his *Walking Man* "proof of the working of a mind tainted with sadism"—and the second entirely an interior rapture, no longer the assertion of selfhood but rather the collection of an identity (motionless or moving, rapt or reft, suggestive or stark) from the very lineaments of what is *other:* this private creation of Turner and Rodin is the highest expression Western art can show of an identification with what is not the self but seen, the making of an inwardness from what is outside—as I have said, an *ecstatics* of art... In considering then the remarkable analogies between Rodin and Turner, let us not forget that to each genius was attached a young and voluble literary man whose attentions were not so welcome to the artist as they are to us: Ruskin who by his late twenties was determined to dedicate his fortune and vocabulary (both enormous) to the exposition of his "earthly master"; Rilke who at the same age served as Rodin's secretary, and though ignominiously dismissed managed to patch up the misunderstanding by patience, admiration, servility even—and of course by one of the most beautiful essays in the entire range of art criticism, which Rodin may never have read. One sentence from each writer must suffice to manifest the degree of suffusion, the deep dye these passionate young men had taken:

FRAGMENTS OF A "RODIN"

Rodin and Rodin only would follow and render that mystery of decided line, that distinct, sharp, visible but unintelligible and inextricable richness, which, examined part by part, is to the eye nothing but confusion and defeat, which, taken as a whole, is all unity, symmetry and truth.

Turner was a worker whose only desire was to penetrate with all his forces into the humble and difficult significance of his means; therein lay a certain renunciation of Life, but in just this renunciation lay his triumph, for Life entered into his work: his art was not built upon a great idea but upon a craft, in which the fundamental element was the surface, was what is seen.

Ah no, I have the names reversed: the first sentence is by Ruskin, the second by Rilke. There is always a confusion, is there not, when literary men meddle with art?

III

Between the "wrong" Rodin mutilated on the steps of the Cleveland Museum and the undivulged Rodin I have suggested as an antidote, between the emblem of an abject ideology and the ecstatics of a released identity, it is good—it is corrective—to stand a moment before the masterpiece of Rodin's sculpture and the supreme sculptural expression of the nineteenth century, *The Gates of Hell*, begun in 1880, left unfinished (in plaster) and cast only a decade after his death. The first cast is in Philadelphia, the second in Paris, both gifts of the same American millionaire who created the Rodin Museum in the former city and who restored Rodin's villa outside the latter, housing hundreds of original plaster studies and drawings which had been inadequately protected—a gesture never acknowledged by the French authorities. Looking at the spectacular patina of the bronze, the terrific shadows which are Dantesque indeed, one is easily distracted from the Master's intention:

My sole idea is simply one of *color* and *effect*...I have revived

the means employed by Renaissance artists, for example, this
mélange of figures, some in low relief, others in the round, in
order to obtain those beautiful blond shadows which produce
all the softness...

Rodin had hoped to make the individual figures in wax, at-
taching them to the plaster frame, which would have created
even subtler "blond shadows", but the technique was imprac-
ticable, and year after year the portal remained in his studio,
endlessly altered, figures added, removed, shifting in scale
and inclusiveness, the only fixed point being the tombs near
the base of the doors, which were the last major additions
before Rodin's death. Almost all the images we associate
most readily—and not always with relish—with the sculptor
are here, frequently in a context which challenges the conno-
tations they have come to have for us: *The Thinker, Adam,
Eve, The Prodigal Son, Crouching Woman, The Three
Shades, The Old Courtesan, The Kiss, Fugit Amor, Ugolino...*
In particular Man as *The Thinker* replaces Christ in the judg-
ment seat, and in general chaos and flux supplant the hier-
archies of doctrine. For Rodin himself, the work was as pri-
vate as the swiftest of his drawings, the most summary of his
clay sketches, and its inflection—though I have called it ec-
static, though I am certain it is exalted and even exultant—is
catastrophic. Michelangelo called Ghiberti's doors *The Gates
of Paradise,* and surely Rodin accepted the challenge in call-
ing his own *The Gates of Hell.* They are the consummate
expression of that encyclopedic impulse of the nineteenth cen-
tury, that effort to gain access to prophecy by means of proc-
ess, which we link to Courbet's *Atelier,* for example, and to
the *Comédie Humaine* of Balzac—Balzac, of whom Rodin
gives us the most *unwavering,* the most Promethean image—
for their subject is not so much a version of Dante as an in-
version: *La Tragédie Humaine.*

Corrective, then, to pre-empt this apocalyptic and yet inti-
mate Rodin—apocalyptic in the sense that he creates a world
of total metaphor, in which everything is potentially identical

FRAGMENTS OF A "RODIN"

with everything else, as though it were all inside a single infinite and eternal body. The last great artist for whom art, nature and religion are identical, Rodin was faithful to what Pater calls the culture, the administration of the visible world, and he merited Revelation, which might solace his heart in the inevitable fading of that. His delights, as it says in Scripture, were with the sons of men, and in *The Gates of Hell* we read their fortune; it is ours.

—RICHARD HOWARD
1970

xiii

PREFACE

NOT far from Paris, on the Seine, near Meudon, is a hamlet bearing the delightful name of Val-Fleury. Crowning the little hill above this village rises a group of buildings which in their charm and originality at once attract interest. You might almost guess that they belonged to an artist, and it is there, in fact, that Auguste Rodin has made his home.

Approaching, you find that the main buildings are three. The first, a Louis XIII. pavilion of red brick and freestone with a high-gabled roof, serves as his dwelling. Close by stands a great rotunda, entered through a columned portico, which is the one that in 1900 sheltered the special exhibition of Rodin's work at the angle of the Pont de l'Alma in Paris; as it pleased him, he had it re-

erected upon this new site and uses it as his atelier.
A little further on at the edge of the hill, which
here falls steeply away, you see an eighteenth-cen-
tury château — or rather only a façade — whose
fine portal, under a triangular pediment, frames a
wrought-iron gate; of this, more later.

This group, so diverse in character, is set in the
midst of an idyllic orchard. The spot is certainly
one of the most enchanting in the environs of
Paris. Nature has done much for it, and the sculp-
tor who settled here has beautified it with all the
embellishments that his taste could suggest.

Last year, at the close of a beautiful day in
May, as I walked with Auguste Rodin beneath the
trees that shade his charming hill, I confided to
him my wish to write, from his dictation, his ideas
upon Art.

"You are an odd fellow," he said. " So you
are still interested in Art! It is an interest that
is out-of-date.

" To-day, artists and those who love artists seem

PREFACE

like fossils. Imagine a megatherium or a diplodocus stalking the streets of Paris! There you have the impression that we must make upon our contemporaries. Ours is an epoch of engineers and of manufacturers, not one of artists.

" The search in modern life is for utility; the endeavor is to improve existence materially. Every day, science invents new processes for the feeding, clothing, or transportation of man; she manufactures cheaply inferior products in order to give adulterated luxuries to the greatest number — though it is true that she has also made real improvements in all that ministers to our daily wants. But it is no longer a question of spirit, of thought, of dreams. Art is dead.

" Art is contemplation. It is the pleasure of the mind which searches into nature and which there divines the spirit by which Nature herself is animated. It is the joy of the intellect which sees clearly into the Universe and which recreates it, with conscientious vision. Art is the most sublime

7

PREFACE

mission of man, since it is the expression of thought seeking to understand the world and to make it understood.

" But to-day, mankind believes itself able to do without Art. It does not wish to meditate, to contemplate, to dream; it wishes to enjoy physically. The heights and the depths of truth are indifferent to it; it is content to satisfy its bodily appetites. Mankind to-day is brutish — it is not the stuff of which artists are made.

" Art, moreover, is taste. It is the reflection of the artist's heart upon all the objects that he creates. It is the smile of the human soul upon the house and upon the furnishing. It is the charm of thought and of sentiment embodied in all that is of use to man. But how many of our contemporaries feel the necessity of taste in house or furnishing? Formerly, in old France, Art was everywhere. The smallest bourgeois, even the peasant, made use only of articles which pleased the eye. Their chairs, their tables, their pitchers and

their pots were beautiful. To-day Art is banished from daily life. People say that the useful need not be beautiful. All is ugly, all is made in haste and without grace by stupid machines. The artist is regarded as an antagonist. Ah, my dear Gsell, you wish to jot down an artist's musings. Let me look at you! You really are an extraordinary man!"

"I know," I said, "that Art is the least concern of our epoch. But I trust that this book may be a protest against the ideas of to-day. I trust that your voice may awaken our contemporaries and help them to understand the crime they commit in losing the best part of our national inheritance — an intense love of Art and Beauty."

"May the gods hear you!" Rodin answered.

.

We were walking along the rotunda which serves as the atelier. There under the peristyle many charming bits of antique sculpture have found shelter. A little vestal, half-veiled, faces a grave

orator wrapped in his toga, while not far from
them a cupid rides triumphant upon a great sea-
monster. In the midst of these figures two Corin-
thian columns of charming grace raise their shafts
of rose-colored marble. The collection here of
these precious fragments shows the devotion of my
host to the art of Greece and Rome.

Two swans were drowsing upon the bank of a
deep pool. As we passed they unwound their long
necks and hissed with anger. Their savageness
prompted me to the remark that this bird lacks
intelligence, but Rodin replied, laughing:

"They have that of line, and that is enough!"

As we strolled on, small cylindrical altars in
marble, carved with garlands, appeared here and
there in the shade. Beneath a bower, clothed with
the luxuriant green of a sophora, a young Mithra
without a head sacrificed a sacred bull. At a
green crossway an Eros slept upon his lion-skin,
sleep having overcome him who tames the beasts.

"Does it not seem to you," Rodin asked, "that

verdure is the most appropriate setting for antique sculpture? This little drowsy Eros — would you not say that he is the god of the garden? His dimpled flesh is brother to this transparent and luxuriant foliage. The Greek artists loved nature so well that their works bathe in it as in their element."

Let us notice this attitude of mind. We place statues in a garden to beautify the garden. Rodin places them there that they may be beautified by the garden. For him, Nature is always the sovereign mistress and the infinite perfection.

A Greek amphora, in rose-colored clay, which in all probability had lain for centuries under the sea, so encrusted is it with charming sea-growths, lies upon the ground at the foot of a box-tree. It seems to have been forgotten there, and yet it could not have been presented to our eyes with more grace — for what is natural is the supreme of taste.

Further on we see a torso of Venus. The

breasts are hidden by a handkerchief knotted be-
hind the back. Involuntarily one thinks of some
Tartuffe who, prompted by false modesty, has
felt it his duty to conceal these charms.

> "Par de pareils objêts les âmes sont blessées
> Et cela fait venir de coupables pensées."

But surely my host has nothing in common with
Molière's prude. He himself explained his reason.

"I tied that around the breast of this statue,"
he said, "because that part is less beautiful than
the rest."

Then, through a door which he unbolted, he led
me on to the terrace where he has raised the eigh-
teenth-century façade of which I have spoken.

Seen close to, this noble fragment of architec-
ture is imposing. It is a fine portal raised upon
eight steps. On the pediment, which is supported
by columns, Themis surrounded by Loves is carved.

"Formerly," said my host, "this beautiful
château rose on the slope of a neighboring hill at

PREFACE

Issy. I often admired it as I passed. But the land speculators bought it and tore it down." As he spoke his eyes flashed with anger. " You cannot imagine," he continued, "what horror seized me when I saw this crime committed. To tear down this glorious building! It affected me as much as though these criminals had mangled the fair body of a virgin before my eyes!"

Rodin spoke these words in a tone of deep devotion. You felt that the firm white body of the young girl was to him the masterpiece of creation, the marvel of marvels!

He continued:

" I asked the sacrilegious rascals not to scatter the materials and to sell them to me. They consented. I had all the stones brought here to put them together again as well as I could. Unfortunately, as you see, I have as yet raised only one wall."

In fact, in his impatience to enjoy this keen artistic pleasure, Rodin has not followed the usual

and logical method which consists in raising all parts of a building at once. Up to the present time he has rebuilt only one side of the château, and when you approach to look through the iron entrance gate, you see only broken ground where lines of stones indicate the plan of the building to be. Truly a château of dreams! An artist's château!

"Verily," murmured my host, "those old architects were great men, especially when one compares them with their unworthy successors of to-day!"

So speaking, he drew me to a point on the terrace from which the outline of the façade seemed to him most beautiful.

"See," he cried, "how harmoniously the silhouette cuts the silvery sky, and how it dominates the valley which lies below us."

Lost in ecstasy, his loving gaze enveloped this monument of a day that is past and all the landscape.

From the height on which we stood our eyes

PREFACE

took in an immense expanse. There, below, the
Seine, mirroring long lines of tall poplars, traces
a great loop of silver as it rushes towards the solid
bridge at Sèvres. . . . Still further, the white
spire of Saint-Cloud against a green hillside, the
blue heights of Suresnes and Mont Valerian seem
powdered with a mist of dreams.

To the right, Paris, gigantic Paris, spreads away
to the horizon her great seed plot, sown with in-
numerable houses, so small in the distance that
one might hold them in the palm of one's hand.
Paris, vision at once monstrous and sublime, colos-
sal crucible wherein bubbles unceasingly that strange
mixture of pains and pleasures, of active forces and
of fevered ideals!

<div align="right">Paul Gsell.</div>

CONTENTS

ILLUSTRATIONS

CHAPTER I
REALISM IN ART

CHAPTER I

REALISM IN ART

A T the end of the long rue de l'Université, close to the Champ-de-Mars, in a corner, so deserted and monastic that you might think yourself in the provinces, is the Dépôt des Marbres.

Here in a great grass-grown court sleep heavy grayish blocks, presenting in places fresh breaks of frosted whiteness. These are the marbles reserved by the State for the sculptors whom she honors with her orders.

Along one side of this courtyard is a row of a dozen ateliers which have been granted to different sculptors. A little artist city, marvellously tranquil, it seems the fraternity house of a new order. Rodin occupies two of these cells; in one he houses the plaster cast of his Gate of Hell, astonishing

even in its unfinished state, and in the other he
works.

More than once I have been to see him here
towards evening, when his day of toil drew to its
close, and taking a chair, I have waited for the
moment when the night would oblige him to stop,
and I have studied him at his work. The desire
to profit by the last rays of daylight threw him
into a fever.

I see him now, rapidly shaping his little figures
from the clay. It is a game which he enjoys in
the intervals of the more patient care which he
gives to his big figures. These sketches flung off
on the instant delight him, because they permit him
to seize the fleeting beauty of a gesture whose fugi-
tive truth would escape deeper and longer study.

His method of work is singular. In his atelier
several nude models walk about or rest.

Rodin pays them to furnish him constantly with
the sight of the nude moving with all the freedom
of life. He observes them without ceasing, and it

is thus that he has long since become familiar
with the sight of muscles in movement. The nude,
which for us moderns is an exceptional revelation
and which even for the sculptors is generally only
an apparition whose length is limited to a sitting,
has become to Rodin a customary sight. The con-
stant familiarity with the human body which the
ancient Greeks acquired in watching the games —
the wrestling, the throwing of the discus, the box-
ing, the gymnastics, and the foot races — and
which permitted their artists to talk naturally on
the subject of the nude, the creator of the *Penseur*
has made sure of by the continual presence of un-
clothed human beings who come and go before his
eyes. In this way he has learned to read the feel-
ings as expressed in every part of the body. The
face is generally considered as the only mirror of
the soul; the mobility of the features of the face
seems to us the only exterior expression of the
spiritual life. In reality there is not a muscle of
the body which does not express the inner varia-

tions of feeling. All speak of joy or of sorrow, of enthusiasm or of despair, of serenity or of madness. Outstretched arms, an unconstrained body, smile with as much sweetness as the eyes or the lips. But to be able to interpret every aspect of the flesh, one must have been drawn patiently to spell out and to read the pages of this beautiful book. The masters of the antique did this, aided by the customs of their civilization. Rodin does this in our own day by the force of his own will.

He follows his models with his earnest gaze, he silently savors the beauty of the life which plays through them, he admires the suppleness of this young woman who bends to pick up a chisel, the delicate grace of this other who raises her arms to gather her golden hair above her head, the nervous vigor of a man who walks across the room; and when this one or that makes a movement that pleases him, he instantly asks that the pose be kept. Quick, he seizes the clay, and a little figure is under way; then with equal haste he

passes to another, which he fashions in the same manner.

One evening when the night had begun to darken the atelier with heavy shadows, I had a talk with the master on his method.

" What astonishes me in you," said I, " is that you work quite differently from your confrères. I know many of them and have seen them at work. They make the model mount upon a pedestal called the throne, and they tell him to take such or such a pose. Generally they bend or stretch his arms and legs to suit them, they bow his head or straighten his body exactly as though he were a lay figure. Then they set to work. You, on the contrary, wait till your models take an interesting attitude, and then you reproduce it. So much so that it is you who seem to be at their orders rather than they at yours."

Rodin, who was engaged in wrapping his *figurines* in damp cloths, answered quietly:

" I am not at their orders, but at those of

Nature! My confrères doubtless have their reasons for working as you have said. But in thus doing violence to nature and treating human beings like puppets, they run the risk of producing lifeless and artificial work.

"As for me, seeker after truth and student of life as I am, I shall take care not to follow their example. I take from life the movements I observe, but it is not I who impose them.

"Even when a subject which I am working on compels me to ask a model for a certain fixed pose, I indicate it to him, but I carefully avoid touching him to place him in the position, for I will reproduce only what reality spontaneously offers me.

"I obey Nature in everything, and I never pretend to command her. My only ambition is to be servilely faithful to her."

"Nevertheless," I answered with some malice, "it is not nature exactly as it is that you evoke in your work."

REALISM IN ART

He stopped short, the damp cloth in his hands. "Yes, exactly as it is!" he replied, frowning.

"You are obliged to alter — "

"Not a jot!"

"But, after all, the proof that you do change it is this, that the cast would give not at all the same impression as your work."

He reflected an instant and said: "That is so! Because the cast is less true than my sculpture!

"It would be impossible for any model to keep an animated pose during all the time that it would take to make a cast from it. But I keep in my mind the ensemble of the pose and I insist that the model shall conform to my memory of it. More than that, — the cast only reproduces the exterior; I reproduce, besides that, the spirit which is certainly also a part of nature.

"I see all the truth, and not only that of the outside.

"I accentuate the lines which best express the spiritual state that I interpret."

REALISM IN ART

As he spoke he showed me on a pedestal near by one of his most beautiful statues, a young man kneeling, raising suppliant arms to heaven. All his being is drawn out with anguish. His body is thrown backwards. The breast heaves, the throat is tense with despair, and the hands are thrown out towards some mysterious being to which they long to cling.

"Look!" he said to me; "I have accented the swelling of the muscles which express distress. Here, here, there — I have exaggerated the straining of the tendons which indicate the outburst of prayer."

And, with a gesture, he underlined the most vigorous parts of his work.

"I have you, Master!" I cried ironically; "you say yourself that you have *accented, accentuated, exaggerated*. You see, then, that you have changed nature."

He began to laugh at my obstinacy.

"No," he replied. "I have not changed it. Or,

32

rather, if I have done it, it was without suspecting it at the time. The feeling which influenced my vision showed me Nature as I have copied her.

" If I had wished to modify what I saw and to make it more beautiful, I should have produced nothing good."

An instant later he continued:

" I grant you that the artist does not see Nature as she appears to the vulgar, because his emotion reveals to him the hidden truths beneath appearances.

" But, after all, the only principle in Art is to copy what you see. Dealers in æsthetics to the contrary, every other method is fatal. There is no recipe for improving nature.

" The only thing is *to see*.

" Oh, doubtless a mediocre man copying nature will never produce a work of art; because he really looks without *seeing*, and though he may have noted each detail minutely, the result will be flat and without character. But the profession of

artist is not meant for the mediocre, and to them the best counsels will never succeed in giving talent.

" The artist, on the contrary, *sees;* that is to say, that his eye, grafted on his heart, reads deeply into the bosom of Nature.

" That is why the artist has only to trust to his eyes."

CHAPTER II
TO THE ARTIST ALL IN NATURE IS BEAUTIFUL

CHAPTER II

TO THE ARTIST ALL IN NATURE IS BEAUTIFUL

IN Rodin's great atelier at Meudon stands a cast of that statuette, so magnificently ugly, which the great sculptor wrought upon the text of Villon's poem, *La Belle Heaulmière*.

The courtesan, once radiant with youth and grace, is now repulsive with age and decrepitude. Once proud of her beauty, she is now filled with shame at her ugliness.

> " Ha, vieillesse felonne et fière,
> Pourquoi m'as tu si tôt abattue?
> Qui me tient que je ne me fière (frappe)
> Et qu'à ce coup je ne me tue! " [1]

[1] See page 249.

37

TO THE ARTIST

The sculptor has followed the poet step by step. The old hag, more shrivelled than a mummy, mourns her physical decay. Bent double, crouching on her haunches, she gazes despairingly upon her breasts so pitiably shrunken, upon her hideously wrinkled body, upon her arms and legs more knotty than vine stocks.

"Quand je pense, las! au bon temps,
Quelle fus, quelle devenue,
Quand me regarde toute nue
Et je me vois si très changée.
Pauvre, sêche, maigre, menue,
Je suis presque tout enragée!
Qu'est devenue ce front poli,
Ces cheveux blonds. . . .
Ces gentes épaules menues,
Petite tetins, hanches charnues,
Elevées, propres, faictisse (faites à souhait)
A tenir d'amoureuses lices;

C'est d'humaine beauté l'issue!
Les bras courts et les mains contraictes
(contractées),

38

ALL IN NATURE IS BEAUTIFUL

Les épaules toutes bossue.
Mamelles, quoi! toutes retraites (dessechées)
Telles les hanches et que les tettes!
Quant aux cuisses,
Cuisses ne sont plus, mais cuissettes
Grivelées comme saucisses!" [1]

The sculptor does not fall below the poet in realism. On the contrary, his work, in the horror which it inspires, is perhaps even more impressive than the truculent verses of Maître Villon. The skin hangs in flaccid folds upon the skeleton; the ribs stand out beneath the parchment that covers them, and the whole figure seems to totter, to tremble, to shrivel, to shrink away.

Yet from this spectacle, at once grotesque and heartrending, a great sorrow breathes.

For what we have before us is the infinite distress of a poor foolish soul which, enamoured of eternal youth and beauty, looks on helpless at the ignominious disgrace of its fleshly envelope; it is

[1] See page 249.

the antithesis of the spiritual being which demands endless joy and of the body which wastes away, decays, ends in nothingness. The substance perishes, the flesh dies, but dreams and desires are immortal.

This is what Rodin has wished to make us understand.

And I do not think that any other artist has ever pictured old age with such savage crudity, except one. In the Baptistery at Florence you see upon an altar a strange statue by Donatello — an old woman naked, or at least draped only in the long, thin hair which clings foully to her ruined body. It is Saint Magdalene in the desert, bowed with age, offering to God the cruel mortifications to which she subjects her body as a punishment for the care which she formerly lavished upon it.

The savage sincerity of the Florentine master is so great that it is not even surpassed by Rodin himself. But, aside from this, the sentiment of the two works differs completely, for, while Saint Magdalene in her voluntary renunciation seems to grow

more radiant as she sees herself growing more re-
pulsive, the old Heaulmière is terrified at finding
herself like a very corpse.

The modern sculpture is, therefore, much more
tragic than the older work.

One day, having studied this figure in the atelier
for some moments in silence, I said:

" Master, no one admires this astonishing figure
more than I, but I hope you will not be annoyed
if I tell you the effect it produces upon many of
the visitors to the Musée du Luxembourg, especially
upon the women."

" I shall be much obliged to you if you will."

" Well, the public generally turn away from it,
crying, ' Oh, how ugly it is! ' and I have often seen
women cover their eyes with their hands to shut
out the sight."

Rodin laughed heartily.

" My work must be eloquent," he said, " to make
such a vivid impression, and doubtless these are
people who dread stern philosophic truths.

TO THE ARTIST

"But what solely matters to me is the opinion of people of taste, and I have been delighted to gain their approbation for my *Vieille Heaulmière*. I am like that Roman singer who replied to the jeers of the populace: *Equitibus cano*. I sing only for the nobles! that is to say, for the connoisseurs.

"The vulgar readily imagine that what they consider ugly in existence is not fit subject for the artist. They would like to forbid us to represent what displeases and offends them in nature.

"It is a great error on their part.

"What is commonly called *ugliness* in nature can in art become full of great beauty.

"In the domain of fact we call *ugly* whatever is deformed, whatever is unhealthy, whatever suggests the idea of disease, of debility, or of suffering, whatever is contrary to regularity, which is the sign and condition of health and strength: a hunchback is *ugly*, one who is bandy-legged is *ugly*, poverty in rags is *ugly*.

"*Ugly* also are the soul and the conduct of the

immoral man, of the vicious and criminal man, of
the abnormal man who is harmful to society; *ugly*
the soul of the parricide, of the traitor, of the
unscrupulously ambitious.

"And it is right that beings and objects from
which we can expect only evil should be called by
such an odious epithet. But let a great artist or a
great writer make use of one or the other of these
uglinesses, instantly it is transfigured: with a touch
of his fairy wand he has turned it into beauty; it
is alchemy; it is enchantment!

"Let Velasquez paint Sebastian, the dwarf of
Philippe IV. He endows him with such a touch-
ing gaze that we instantly read in it all the painful
secret of this poor afflicted creature, forced, for
his livelihood, to lower his human dignity, to be-
come a plaything, a living bauble. And the more
poignant the martyrdom of the conscience lodged
in this grotesque body, the more beautiful is the
artist's work.

"Let François Millet represent a peasant rest-

ing for a moment as he leans on the handle of his hoe, a wretched man worn by fatigue, baked by the sun, as stupid as a beast of burden dulled by blows — he has only to put into the expression of this poor devil a sublime resignation to the suffering ordained by Destiny, to make this creature of a nightmare become for us the great symbol of all Humanity.

"Let Beaudelaire describe a festering corpse, unclean, viscid, eaten by worms, and let him but imagine his beloved mistress under this frightful aspect, and nothing can equal in splendor his picture of this terrible juxtaposition of beauty which we could wish eternal and the atrocious disintegration which awaits it.

"'Et pourtant vous serez semblable à cette ordure,
 A cette horrible infection.
Etoile de mes yeux, Soleil de ma nature,
 O mon ange et ma passion!
Oui, telle vous serez, o la reine des Grâces
 Après les derniers sacrements.

ALL IN NATURE IS BEAUTIFUL

Quand vous irez sous l'herbe et les floraisons grasses
 Pourrir parmi les ossements.

Alors, o ma Beauté, dîtes à la vermine
 Qui vous mangerez de baisers,
Que j'ai gardé la forme et l'essence divine
 De mes amours décomposés!' [1]

" It is the same when Shakespeare depicts Iago or Richard III., when Racine paints Nero and Narcissus; moral ugliness when interpreted by minds so clear and penetrating becomes a marvellous theme of beauty.

" In fact, in art, only that which has *character* is beautiful.

" *Character* is the essential truth of any natural object, whether ugly or beautiful; it is even what one might call a *double truth*, for it is the inner truth translated by the outer truth; it is the soul, the feelings, the ideas, expressed by the features of a face, by the gestures and actions of a human

[1] See page 250.

45

being, by the tones of a sky, by the lines of a horizon.

"Now, to the great artist, everything in nature has character; for the unswerving directness of his observation searches out the hidden meaning of all things. And that which is considered ugly in nature often presents more *character* than that which is termed beautiful, because in the contractions of a sickly countenance, in the lines of a vicious face, in all deformity, in all decay, the inner truth shines forth more clearly than in features that are regular and healthy.

"And as it is solely the power of *character* which makes for beauty in art, it often happens that the uglier a being is in nature, the more beautiful it becomes in art.

"There is nothing ugly in art except that which is without character, that is to say, that which offers no outer or inner truth.

"Whatever is false, whatever is artificial, whatever seeks to be pretty rather than expressive,

ALL IN NATURE IS BEAUTIFUL

whatever is capricious and affected, whatever smiles without motive, bends or struts without cause, is mannered without reason; all that is without soul and without truth; all that is only a *parade* of beauty and grace; all, in short, that lies, is *ugliness* in art.

"When an artist, intending to improve upon nature, adds green to the springtime, rose to the sunrise, carmine to young lips, he creates ugliness because he lies.

"When he softens the grimace of pain, the shapelessness of age, the hideousness of perversion, when he arranges nature — veiling, disguising, tempering it to please the ignorant public — then he is creating ugliness because he fears the truth.

"To any artist, worthy of the name, all in nature is beautiful, because his eyes, fearlessly accepting all exterior truth, read there, as in an open book, all the inner truth.

"He has only to look into a human face in order to read there the soul within — not a feature de-

ceives him; hypocrisy is as transparent as sincerity
— the line of a forehead, the least lifting of a brow,
the flash of an eye, reveal to him all the secrets of
a heart.

"Or he may study the hidden mind of the ani-
mal. A mixture of feelings and of thoughts, of
dumb intelligences and of rudimentary affections,
he reads the whole humble moral life of the beast
in its eyes and in its movements.

"He is even the confidant of nature. The trees,
the plants talk to him like friends. The old gnarled
oaks speak to him of their kindliness for the human
race whom they protect beneath their sheltering
branches. The flowers commune with him by the
gracious swaying of their stalks, by the singing
tones of their petals — each blossom amidst the
grass is a friendly word addressed to him by nature.

"For him life is an endless joy, a perpetual de-
light, a mad intoxication. Not that all seems good
to him, for suffering, which must often come to
those he loves and to himself, cruelly contradicts his

optimism. But all is beautiful to him because he walks forever in the light of spiritual truth.

"Yes, the great artist, and by this I mean the poet as well as the painter and the sculptor, finds even in suffering, in the death of loved ones, in the treachery of friends, something which fills him with a voluptuous though tragic admiration.

"At times his own heart is on the rack, yet stronger than his pain is the bitter joy which he experiences in understanding and giving expression to that pain. In all existence he clearly divines the purposes of Destiny. Upon his own anguish, upon his own gaping wounds, he fixes the enthusiastic gaze of the man who has read the decrees of Fate. Deceived by a beloved one, he reels beneath the blow; then, standing firm, he looks upon the traitor as a fine example of the base. He salutes ingratitude as an experience which shall enrich his soul. His ecstasy is terrifying at times, but it is still happiness, because it is the continual adoration of truth.

ALL IN NATURE IS BEAUTIFUL

"When he sees beings everywhere destroying each other; when he sees all youth fading, all strength failing, all genius dying, when he is face to face with the will which decreed these tragic laws, more than ever he rejoices in his knowledge, and, seized anew by the passion for truth, he is happy."

CHAPTER III
MODELLING

CHAPTER III

MODELLING

ONE late afternoon, when I was with Rodin in his atelier, darkness set in while we talked.

"Have you ever looked at an antique statue by lamplight?" my host suddenly demanded.

"No, never," I answered, with some surprise.

"I astonish you. You seem to consider the idea of studying sculpture excepting by daylight as an odd whim. Of course you can get the effect as a whole better by daylight. But, wait a moment. I want to show you a kind of experiment which will doubtless prove instructive."

He lighted a lamp as he spoke, took it in his hand, and led me towards a marble statue which

53

stood upon a pedestal in a corner of the atelier.

It was a delightful little antique copy of the *Venus di Medici*. Rodin kept it there to stimulate his own inspiration while he worked.

"Come nearer," he said.

Holding the lamp at the side of the statue and as close as possible, he threw the full light upon the body.

"What do you notice?" he asked.

At the first glance I was extraordinarily struck by what was suddenly revealed to me.

The light so directed, indeed, disclosed numbers of slight projections and depressions upon the surface of the marble which I should never have suspected. I said so to Rodin.

"Good!" he cried approvingly; then, "Watch closely."

At the same time he slowly turned the moving stand which supported the Venus. As he turned, I still noticed in the general form of the body

MODELLING

a multitude of almost imperceptible roughnesses. What had at first seemed simple was really of astonishing complexity. Rodin threw up his head smiling.

"Is it not marvellous?" he cried. "Confess that you did not expect to discover so much detail. Just look at these numberless undulations of the hollow which unites the body to the thigh. Notice all the voluptuous curvings of the hip. And now, here, the adorable dimples along the loins."

He spoke in a low voice, with the ardor of a devotee, bending above the marble as if he loved it.

"It is truly flesh!" he said.

And beaming, he added: "You would think it moulded by kisses and caresses!" Then, suddenly, laying his hand on the statue, "You almost expect, when you touch this body, to find it warm."

A few moments later he said:

"Well, what do you think now of the opinion usually held on Greek art? They say — it is espe-

cially the academic school which has spread abroad this idea — that the ancients, in their cult of the ideal, despised the flesh as low and vulgar, and that they refused to reproduce in their works the thousand details of material reality.

" They pretend that the ancients wished to teach Nature by creating an abstract beauty of simplified form which should appeal only to the intellect and not consent to flatter the senses. And those who talk like this take examples which they imagine they find in antique art as their authority for correcting, for emasculating nature, reducing it to contours so dry, cold, and meagre that they have nothing in common with the truth.

" You have just proved how much they are mistaken.

" Without doubt the Greeks with their powerfully logical minds instinctively accentuated the essential. They accented the dominant traits of the human type; nevertheless they never suppressed living detail. They were satisfied to envelop

it and melt it into the whole. As they were enam-
oured of calm rhythms, they involuntarily subjected
all secondary reliefs which should disturb the seren-
ity of a movement; but they carefully refrained
from entirely obliterating them.

" They never made a method out of falsehood.

" Full of respect and love for Nature, they always
represented her as they saw her. And on every
occasion they passionately testified their worship of
the flesh. For it is madness to believe that they
despised it. Among no other people has the beauty
of the human body excited a more sensuous tender-
ness. A transport of ecstasy seems to hover over
all the forms that they modelled.

" Thus is explained the unbelievable difference
which separates the false academic ideal from Greek
art. While among the ancients the generalization
of lines is totalization, a result made up of all the
details, the academic simplification is an impoverish-
ment, an empty bombastry. While life animates
and warms the palpitating muscles of the Greek

57

statues, the inconsistent dolls of academic art look as if they were chilled by death."

He was silent for a time, then —

" I will tell you a great secret. Do you know how the impression of actual life, which we have just felt before that Venus, is produced?

" By the *science of modelling*.

" These words seem banal to you, but you will soon gauge their importance.

" The *science of modelling* was taught me by one Constant, who worked in the atelier where I made my début as a sculptor. One day, watching me model a capital ornamented with foliage — ' Rodin,' he said to me, ' you are going about that in the wrong way. All your leaves are seen flat. That is why they do not look real. Make some with the tips pointed at you, so that, in seeing them, one has the sensation of depth.' I followed his advice and I was astounded at the result that I obtained. ' Always remember what I am about to tell you,' went on Constant. ' Henceforth, when you carve,

MODELLING

never see the form in length, but always in thick-
ness. Never consider a surface except as the ex-
tremity of a volume, as the point, more or less large,
which it directs towards you. In that way you
will acquire the *science of modelling*.'

" This principle was astonishingly fruitful to me.
I applied it to the execution of figures. Instead
of imagining the different parts of a body as sur-
faces more or less flat, I represented them as pro-
jectures of interior volumes. I forced myself to
express in each swelling of the torso or of the limbs
the efflorescence of a muscle or of a bone which lay
deep beneath the skin. And so the truth of my
figures, instead of being merely superficial, seems to
blossom from within to the outside, like life itself.

" Now I have discovered that the ancients prac-
tised precisely this method of modelling. And it is
certainly to this technique that their works owe at
once their vigor and their palpitating suppleness."

Rodin contemplated afresh his exquisite Greek
Venus. And suddenly he said:

59

MODELLING

"In your opinion, Gsell, is color a quality of painting or of sculpture?"

"Of painting, naturally."

"Well, then, just look at this statue."

So saying, he raised the lamp as high as he could in order to light the antique torso from above.

"Just see the high lights on the breasts, the heavy shadows in the folds of the flesh, and then this paleness, these vaporous half-tones, trembling over the most delicate portions of this divine body, these bits so finely shaded that they seem to dissolve in air. What do you say to it? Is it not a great symphony in black and white?"

I had to agree.

"As paradoxical as it may seem, a great sculptor is as much a colorist as the best painter, or rather, the best engraver.

"He plays so skilfully with all the resources of relief, he blends so well the boldness of light with the modesty of shadow, that his sculptures please one as much as the most charming etchings.

60

MODELLING

" Now color — it is to this remark that I wished to lead — is the flower of fine modelling. These two qualities always accompany each other, and it is these qualities which give to every masterpiece of the sculptor the radiant appearance of living flesh."

CHAPTER IV
MOVEMENT IN ART

CHAPTER IV

MOVEMENT IN ART

THERE are two statues by Rodin at the Musée du Luxembourg which especially attract and hold me; *l'Age d'Airain* (the Iron Age) and *Saint-Jean-Baptiste*. They seem even more full of life than the others, if that is possible. The other works of the Master which bear them company are certainly all quivering with truth; they all produce the impression of real flesh, they all breathe, but these move.

One day in the Master's atelier at Meudon I told him my especial fondness for these two figures.

" They are certainly among those in which I have carried imitative art farthest," he replied. " Though I have produced others whose animation

is not less striking; for example, my *Bourgeois de Calais*, my *Balzac*, my *Homme qui marche* (Man walking).

"And even in those of my works in which action is less pronounced, I have always sought to give some indication of movement. I have very rarely represented complete repose. I have always endeavored to express the inner feelings by the mobility of the muscles.

"This is so even in my busts, to which I have often given a certain slant, a certain obliquity, a certain expressive direction, which would emphasize the meaning of the physiognomy.

"Art cannot exist without life. If a sculptor wishes to interpret joy, sorrow, any passion whatsoever, he will not be able to move us unless he first knows how to make the beings live which he evokes. For how could the joy or the sorrow of an inert object — of a block of stone — affect us? Now, the illusion of life is obtained in our art by good modelling and by movement. These two

qualities are like the blood and the breath of all good work."

" Master," I said, " you have already talked to me of modelling, and I have noticed that since then I am better able to appreciate the master-pieces of sculpture. I should like to ask a few questions about movement, which, I feel, is not less important.

"When I look at your figure of the *Bronze Age,* who awakes, fills his lungs and raises high his arms; or at your *Saint John,* who seems to long to leave his pedestal to carry abroad his words of faith, my admiration is mixed with amazement. It seems to me that there is sorcery in this science which lends movement to bronze. I have also studied other *chefs-d'œuvre* of your great prede-cessors; for example, *Maréchal Ney* and the *Mar-seillaise* by Rude, the *Dance* by Carpeaux, as well as Barye's wild animals, and I confess that I have never found any satisfactory explanation for the effect which these sculptures produce upon me. I

continue to ask myself how such masses of stone and iron can possibly seem to move, how figures so evidently motionless can yet appear to act and even to lend themselves to violent effort."

"As you take me for a sorcerer," Rodin answered, "I shall try to do justice to my reputation by accomplishing a task much more difficult for me than animating bronze — that of explaining how I do it.

"Note, first, that *movement is the transition from one attitude to another.*

"This simple statement, which has the air of a truism, is, to tell the truth, the key to the mystery.

"You have certainly read in Ovid how Daphne was transformed into a bay-tree and Progne into a swallow. This charming writer shows us the body of the one taking on its covering of leaves and bark and the members of the other clothing themselves in feathers, so that in each of them one still sees the woman which will cease to be and the tree or bird which she will become. You remember,

too, how in Dante's *Inferno* a serpent, coiling itself
about the body of one of the damned, changes into
man as the man becomes reptile. The great poet
describes this scene so ingeniously that in each of
these two beings one follows the struggle between
two natures which progressively invade and sup-
plant each other.

"It is, in short, a metamorphosis of this kind
that the painter or the sculptor effects in giving
movement to his personages. He represents the
transition from one pose to another — he indicates
how insensibly the first glides into the second. In
his work we still see a part of what was and we
discover a part of what is to be. An example will
enlighten you better.

"You mentioned just now the statue of Marshal
Ney by Rude. Do you recall the figure clearly?"

"Yes," I said. "The hero raises his sword,
shouting 'Forward' to his troops at the top of his
voice."

"Exactly! Well — when you next pass that

statue, look at it still more closely. You will then notice this: the legs of the statue and the hand which holds the sheath of the sabre are placed in the attitude that they had when he drew — the left leg is drawn back so that the sabre may be easily grasped by the right hand, which has just drawn it; and as for the left hand, it is arrested in the air as if still offering the sheath.

" Now examine the body. It must have been slightly bent toward the left at the moment when it performed the act which I have described, but here it is erect, here is the chest thrown out, here is the head turning towards the soldiers as it roars out the order to attack; here, finally, is the right arm raised and brandishing the sabre.

" So there you have a confirmation of what I have just said; the movement in this statue is only the change from a first attitude — that which the Marshal had as he drew his sabre — into a second, that which he had as he rushes, arm aloft, upon the enemy.

side in order to aid the leg which is behind to come forward. Now, the science of the sculptor has consisted precisely in imposing all these facts upon the spectator in the order in which I have stated them, so that their succession will give the impression of movement.

Moreover, the gesture of Saint John, like that of the Iron Age, contains a spiritual significance. The prophet moves with an almost automatic solemnity. You almost believe you hear his footsteps, as you do those in the statue of the *Commander*. You feel that a force at once mysterious and formidable sustains and impels him. So the act of walking, usually a commonplace movement, here becomes majestic because it is the accomplishment of a divine mission.

" Have you ever attentively examined instantaneous photographs of walking figures?" Rodin suddenly asked me.

Upon my reply in the affirmative, " Well, what did you notice?"

73

"That they never seem to advance. Generally they seem to rest motionless on one leg or to hop on one foot."

"Exactly! Now, for example, while my Saint John is represented with both feet on the ground, it is probable that an instantaneous photograph from a model making the same movement would show the back foot already raised and carried toward the other. Or else, on the contrary, the front foot would not yet be on the ground if the back leg occupied in the photograph the same position as in my statue.

"Now it is exactly for that reason that this model photographed would present the odd appearance of a man suddenly stricken with paralysis and petrified in his pose, as it happened in the pretty fairy story to the servants of the Sleeping Beauty, who were all suddenly struck motionless in the midst of their occupations.

"And this confirms what I have just explained to you on the subject of movement in art. If, in

fact, in instantaneous photographs, the figures, though taken while moving, seem suddenly fixed in mid-air, it is because, all parts of the body being reproduced exactly at the same twentieth or fortieth of a second, there is no progressive development of movement as there is in art."

"I understand you perfectly, Master," I answered. "But it seems to me, if you will excuse me for risking the remark, that you contradict yourself."

"How so?"

"Have you not declared many times to me that the artist ought always to copy nature with the greatest sincerity?"

"Without doubt, and I maintain it."

"Well, then, when in the interpretation of movement he completely contradicts photography, which is an unimpeachable mechanical testimony, he evidently alters truth."

"No," replied Rodin, "it is the artist who is truthful and it is photography which lies, for in

75

reality time does not stop, and if the artist succeeds in producing the impression of a movement which takes several moments for accomplishment, his work is certainly much less conventional than the scientific image, where time is abruptly suspended.

" It is that which condemns certain modern painters who, when they wish to represent horses galloping, reproduce the poses furnished by instantaneous photography.

" Gericault is criticised because in his picture *Epsom Races* (*Course d'Epsom*), which is at the Louvre, he has painted his horses galloping, fully extended, *ventre à terre*, to use a familiar expression, throwing their fore feet forward and their hind feet backward at the same instant. It is said that the sensitive plate never gives the same effect. And, in fact, in instantaneous photography, when the forelegs of a horse are forward, the hind legs, having by their pause propelled the body onward, have already had time to gather themselves under the body in order to recommence the stride, so

that for a moment the four legs are almost gathered together in the air, which gives the animal the appearance of jumping off the ground, and of being motionless in this position.

" Now I believe that it is Gericault who is right, and not the camera, for his horses *appear* to run; this comes from the fact that the spectator from right to left sees first the hind legs accomplish the effort whence the general impetus results, then the body stretched out, then the forelegs which seek the ground ahead. This is false in reality, as the actions could not be simultaneous; but it is true when the parts are observed successively, and it is this truth alone that matters to us, because it is that which we see and which strikes us.

" Note besides that painters and sculptors, when they unite different phases of an action in the same figure, do not act from reason or from artifice. They are naïvely expressing what they feel. Their minds and their hands are as if drawn in the direc-

tion of the movement, and they translate the development by instinct. Here, as everywhere in the domain of art, sincerity is the only rule."

I was silent for several instants, thinking over what he had said.

" Have n't I convinced you? " he asked.

" Yes, indeed. But while admiring this miracle of painting and of sculpture which succeeds in condensing the action of several moments into a single figure, I now ask myself how far they can compete with literature, and especially with the theatre, in the notation of movement. To tell the truth, I am inclined to believe that this competition does not go very far, and that on this score the masters of the brush and chisel are necessarily inferior to those of language."

" Our disadvantage," he exclaimed, " is not as great as you would think. If painting and sculpture can endow figures with motion, they are not forbidden to attempt even more. And at times they succeed in equalling dramatic art by presenting in

the same picture or in the same sculptural group several successive scenes."

"Yes," I replied, "but they cheat, in a way. For I suppose that you are talking of those old compositions which celebrate the entire history of a personage, representing him several times on the same panel in different situations.

"At the Louvre, for example, a small Italian painting of the fifteenth century relates in this way the story of Europa. You first see the young princess playing in the flowery field with her companions, who help her to mount the bull, Jupiter, and further on the same heroine, terrified now, is carried off through the waves by the god."

"That is a very primitive method," Rodin answered, "though it was practised even by great masters — for example, in the ducal palace at Venice this same fable of Europa has been treated in an identical manner by Veronese. But it is in spite of this defect that Caliari's painting is admirable, and I did not refer to any such childish

method: for, as you may imagine, I disapprove of it. To make myself understood, I must ask you first whether you can call to mind *The Embarkation for the Island of Cythera* by Watteau."

" As plainly as if it was before my eyes," I said.

" Then I shall have no trouble in explaining myself. In this masterpiece the action, if you will notice, begins in the foreground to the right and ends in the background to the left.

" What you first notice in the front of the picture, in the cool shade, near a sculptured bust of Cypris garlanded with roses, is a group composed of a young woman and her adorer. 'The man wears a cape embroidered with a pierced heart, gracious symbol of the voyage that he would undertake.

" Kneeling at her side, he ardently beseeches his lady to yield. But she meets his entreaties with an indifference perhaps feigned, and appears absorbed in the study of the decorations on her fan. Close to them is a little cupid, sitting half-

naked upon his quiver. He thinks that the young woman delays too long, and he pulls her skirt to induce her to be less hard-hearted. But still the pilgrim's staff and the script of love lie upon the ground. This is the first scene.

"Here is the second: To the left of the group of which I have spoken is another couple. The lady accepts the hand of her lover, who helps her to arise. She has her back to us, and has one of those blonde napes which Watteau painted with such voluptuous grace.

"A little further is the third scene. The lover puts his arm around his mistress's waist to draw her with him. She turns towards her companions, whose lingering confuses her, but she allows herself to be led passively away.

"Now the lovers descend to the shore and all push laughing towards the barque; the men no longer need to entreat, the women cling to their arms.

"Finally the pilgrims help their sweethearts on

board the little ship, which, decked with flowers
and floating pennons of red silk, rocks like a
golden dream upon the water. The sailors, leaning
on their oars, are ready to row away. And
already, borne by the breezes, little cupids fly
ahead to guide the travellers towards that azure
isle which lies upon the horizon."

" I see, Master, that you love this picture, for
you have remembered every detail," I said.

" It is a delight that one cannot forget. But
have you noted the development of this panto-
mime? Truly now, is it the stage? or is it paint-
ing? One does not know which to say. You see,
then, that an artist can, when he pleases, represent
not only fleeting gestures, but a long *action,* to
employ a term of dramatic art.

" In order to succeed, he needs only to place his
personages in such a manner that the spectator
shall first see those who begin this action, then
those who continue it, and finally those who com-
plete it. Would you like an example in sculpture?"

MOVEMENT IN ART

Opening a book, he searched for a moment and drew out a photograph.

"Here," he said, "is the *Marseillaise* which Rude carved for one of the piers of the Arc de Triomphe.

"Liberty, in a breastplate of brass, cleaving the air with unfolded wings, roars in a mighty voice, 'Aux armes, citoyens!' She raises high her left arm to rally all the brave to her side, and, with the other hand, she points her sword towards the enemy. It is she, beyond question, whom you first see, for she dominates all the work, and her legs, which are wide apart as if she were running, seem like an accent placed above this sublime war-epic. It seems as though one must hear her — for her mouth of stone shrieks as though to burst your ear-drum. But no sooner has she given the call than you see the warriors rush forward. This is the second phase of the action. A Gaul with the mane of a lion shakes aloft his helmet as though to salute the goddess, and here, at his side, is his

young son, who begs the right to go with him —
" I am strong enough, I am a man, I want to
go! " he seems to say, grasping the hilt of a sword.
" Come," says the father, regarding him with ten-
der pride.

" Third phase of the action: a veteran bowed
beneath the weight of his equipment strives to join
them — for all who have strength enough must
march to battle. Another old man, bowed with
age, follows the soldiers with his prayers, and the
gesture of his hand seems to repeat the counsels
that he has given them from his own experience.

" Fourth phase: an archer bends his muscular
back to bind on his arms. A trumpet blares its
frenzied appeal to the troops. The wind flaps the
standards, the lances point forward. The signal is
given, and already the strife begins.

" Here, again, we have a true dramatic compo-
sition acted before us. But while *L'Embarque-
ment pour Cythère* recalls the delicate comedies of
Marivaux, the *Marseillaise* is a great tragedy by

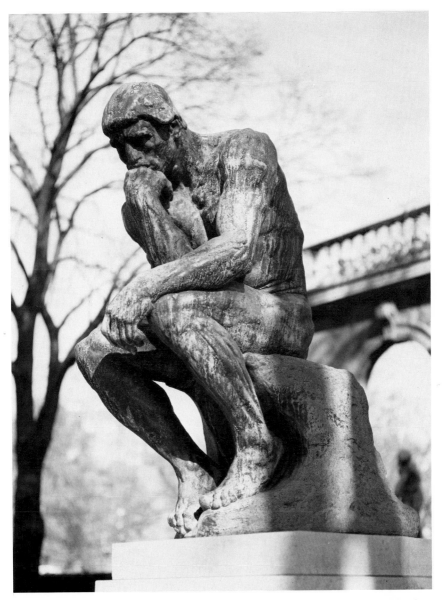

2. The Thinker

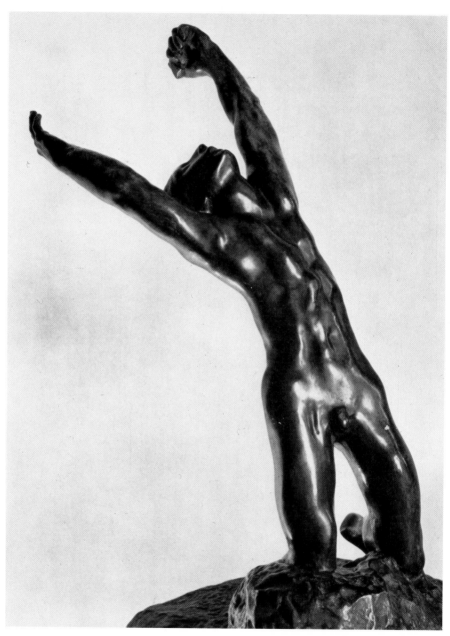

3. The Prodigal Son

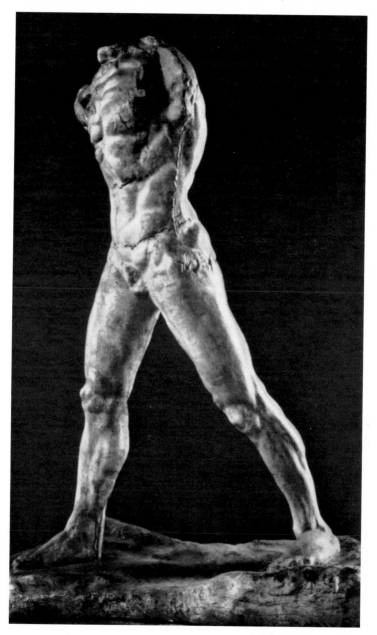

4. The Walking Man

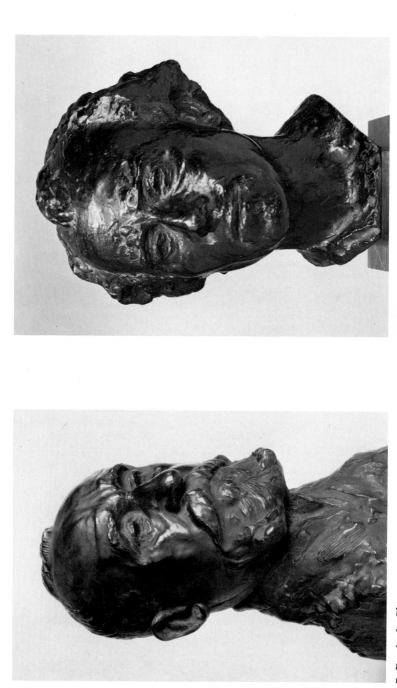

6. Mahler

5. Puvis de Chavannes

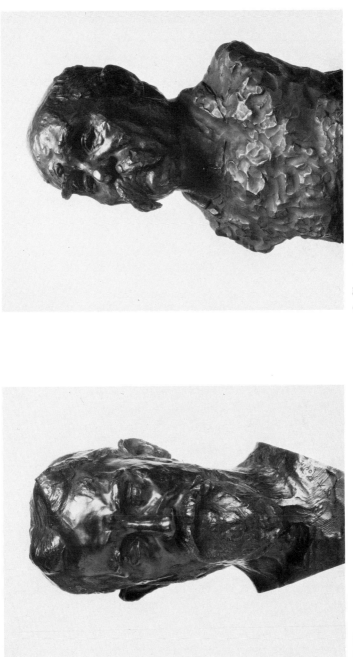

8. Clemenceau

7. Shaw

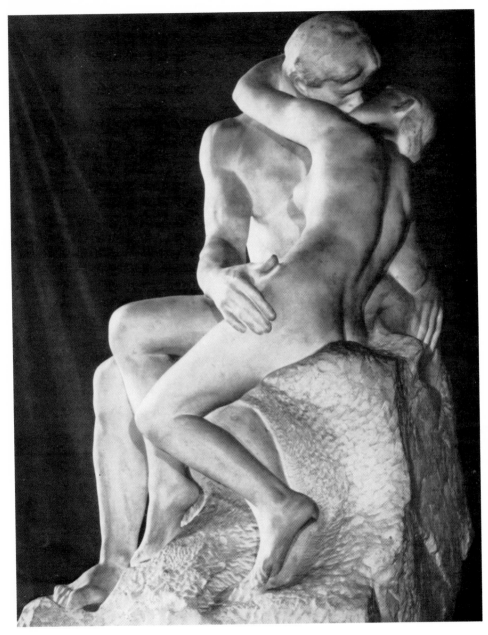

9. The Kiss

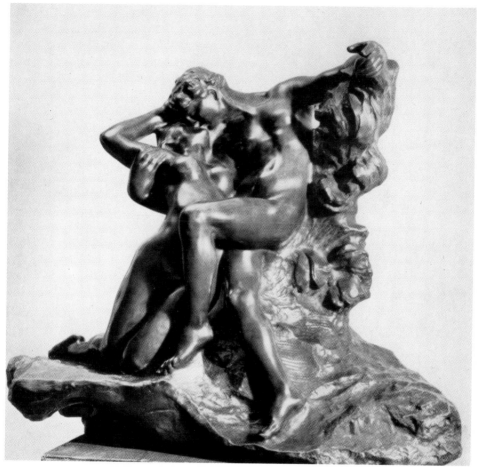

10. Eternal Springtime

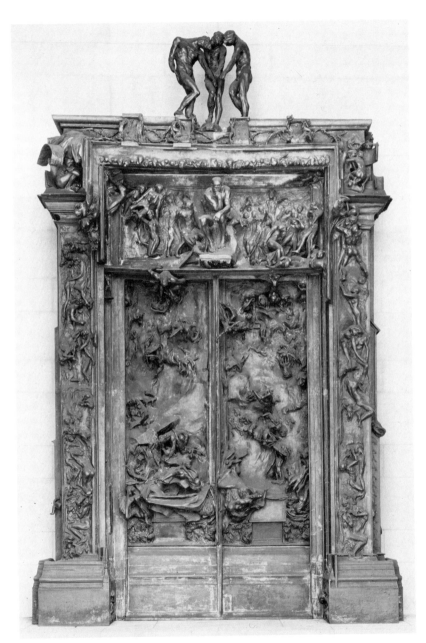

11. The Gates of Hell

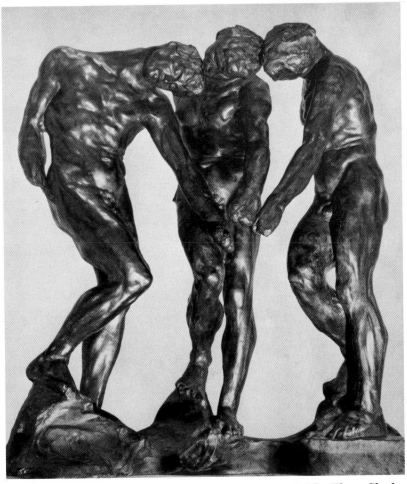

12. The Three Shades

13. Eve

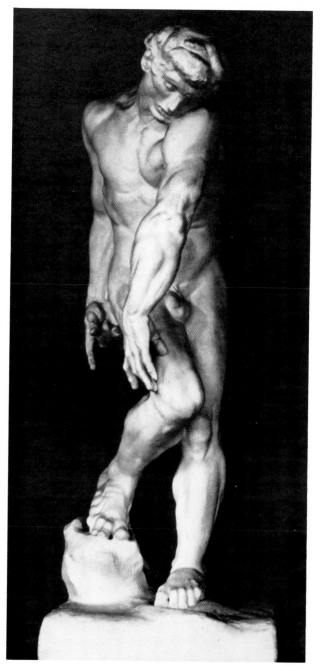

14. Adam

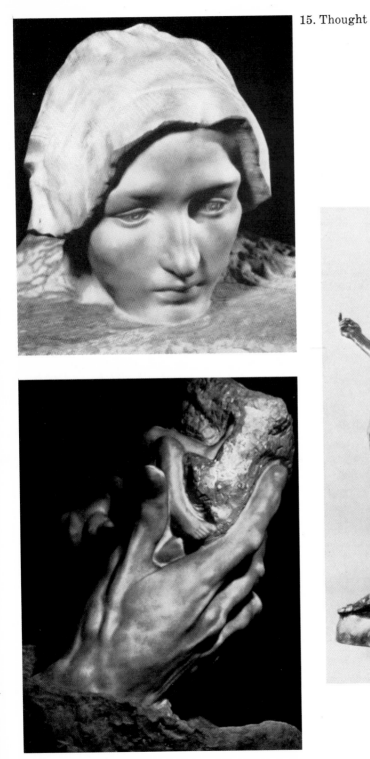

15. Thought

16. The Hand of God

17. St. John the Baptist

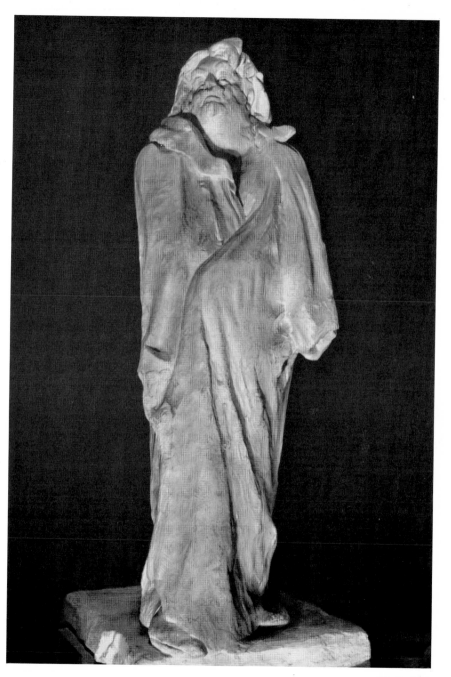

18. Balzac

20. Crouching Woman

19. The Helmet-Maker's Wife (The Old Courtesan)

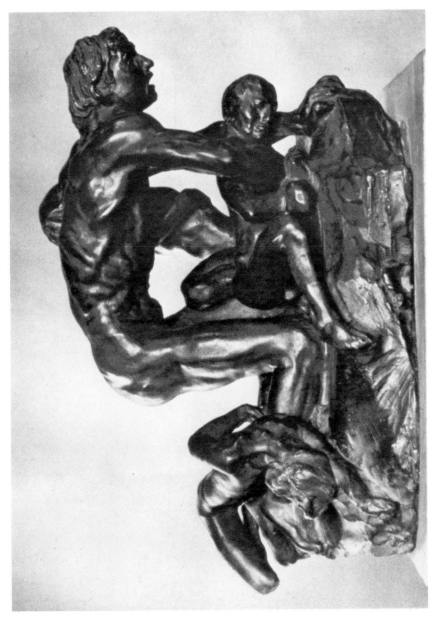

21. Ugolino

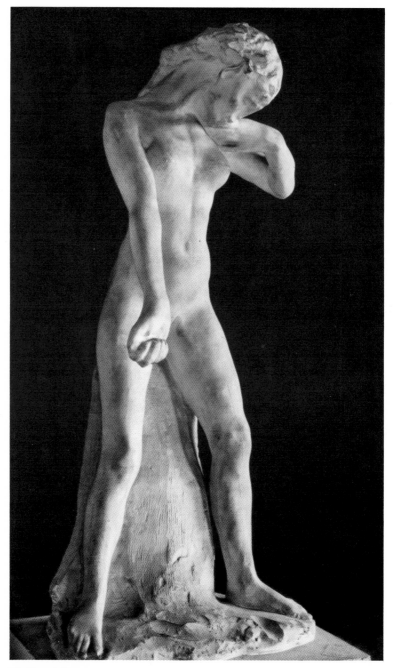

22. Erect Faun

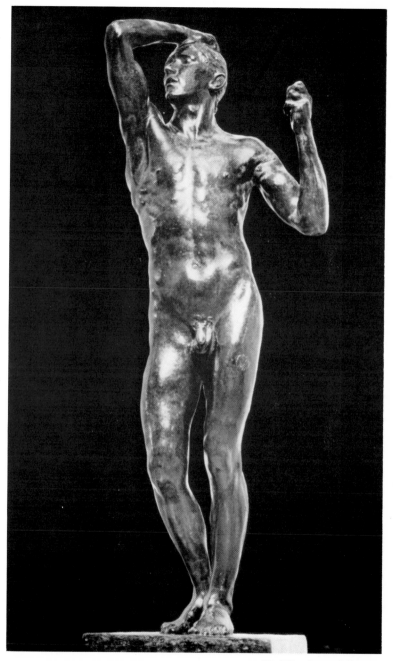

23. The Age of Bronze

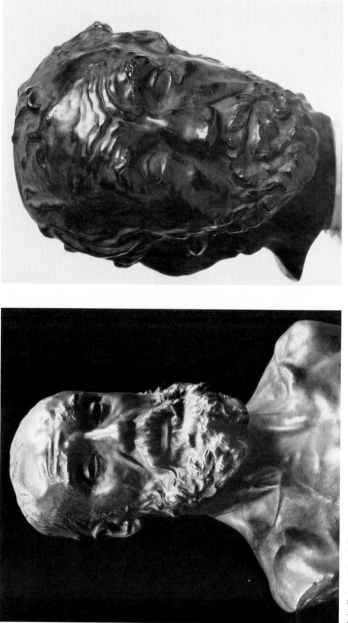

24. Jean-Paul Laurens

25. The Man with the Broken Nose

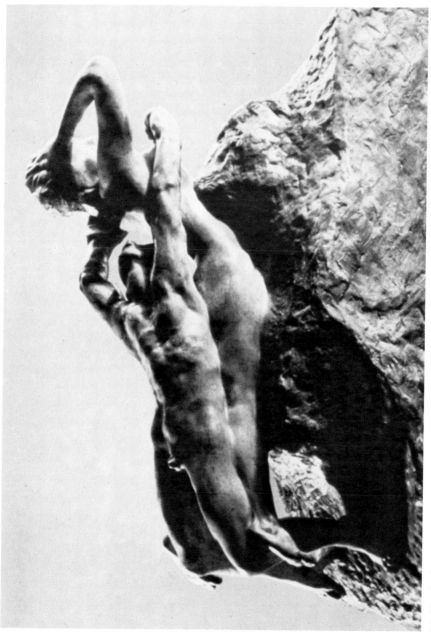

26. Fugit Amor

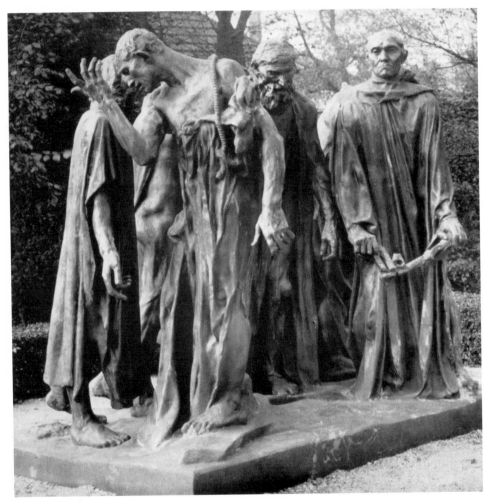

27. The Burghers of Calais

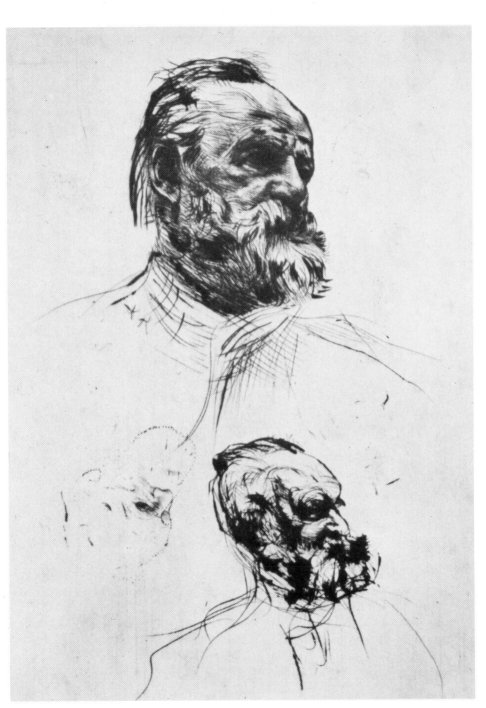

28. Victor Hugo, dry point

29. Pencil, ink and gouache

30-31. Two Studies, ink

32. Three Crouching Women, pencil and watercolor

33. Pencil and watercolor

34. Pencil and watercolor

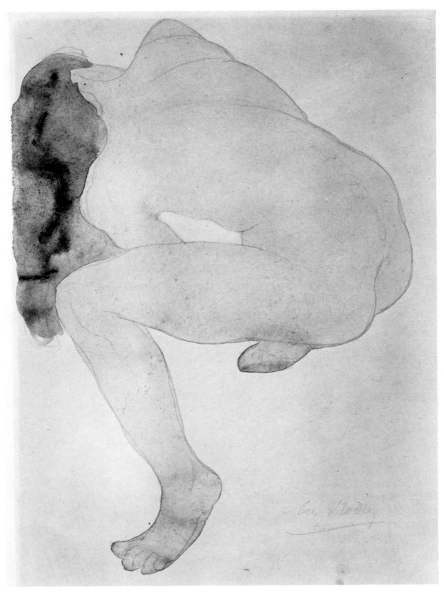

35. Pencil and watercolor

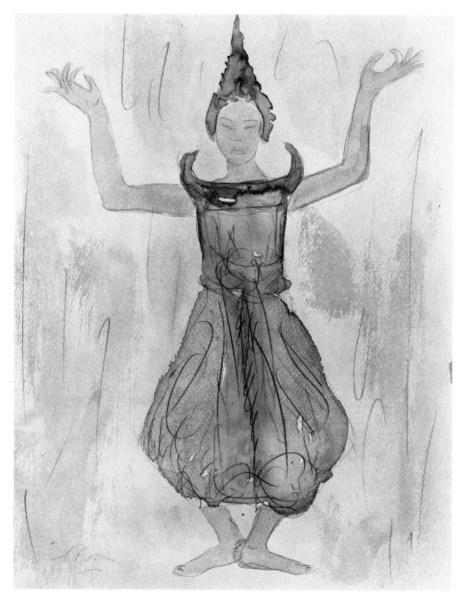

36. Pencil and watercolor

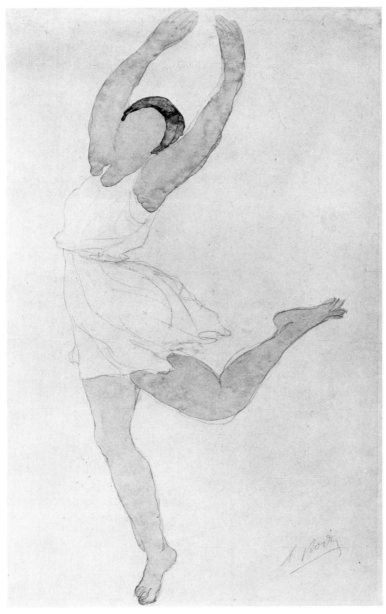

37. Isadora Duncan, pencil and watercolor

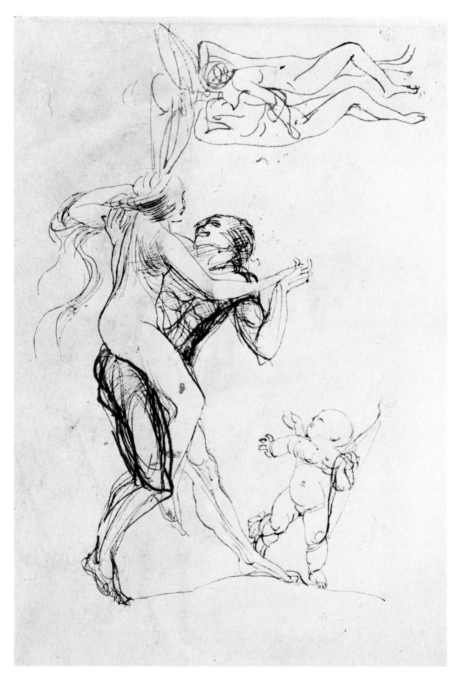

38. Ink

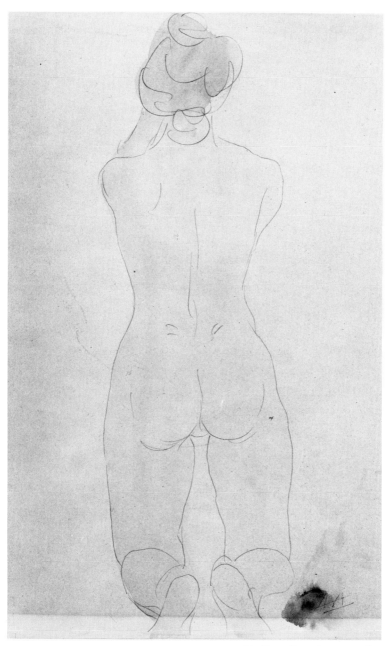

39. Pencil and watercolor

40. Pencil and watercolor

Corneille. I do not know which of the two works I prefer, for there is as much genius in the one as in the other."

And, looking at me with a shade of malicious challenge, he added, " You will no longer say, I think, that sculpture and painting are unable to compete with the theatre? "

" Certainly not." At this instant, I saw in the portfolio where he had replaced the reproduction of the *Marseillaise,* a photograph of his wonderful *Burghers of Calais.* " To prove to you," I said, " that I have profited by your teaching, let me apply it to one of your most beautiful works, for I see that you have yourself put into practice the principles which you have revealed to me.

" Here, in your *Burghers of Calais,* I recognize a scenic succession like that which you have cited in the *chefs-d'œuvre* of Watteau and of Rude.

" The figure in the centre first attracts attention. No one can doubt that it is Eustache de

Saint-Pierre. He bows his venerable head with its long gray hair. He does not hesitate, he is not afraid. He advances steadily, his eyes half closed in silent communion. If he totters a little, it is because of the privations that he has endured during a long siege. It is he who inspires the others, it is he who offered himself first as one of the six notables whose death, according to the conditions of the conqueror, should save their fellow-townsmen from massacre.

" The burgher beside him is not less brave. But if he does not mourn for his own fate, the capitulation of the city causes him terrible sorrow. Holding in his hand the key which he must deliver to the English, he stiffens his whole body in order to find the strength to bear the inevitable humiliation.

" On the same plane with these two, to the left, you see a man who is less courageous, for he walks almost too fast: you would say that, having made up his mind to the sacrifice, he longs

to shorten the time which separates him from his martyrdom.

"And behind these comes a burgher who, holding his head in his hands, abandons himself to violent despair. Perhaps he thinks of his wife, of his children, of those who are dear to him, of those whom his going will leave without support.

"A fifth notable passes his hand before his eyes as if to dissipate some frightful nightmare. He stumbles, death so appals him.

"Finally, here is the sixth burgher, younger than the others. He seems still undecided. A painful anxiety contracts his face. Is it the image of his sweetheart that fills his thoughts? But his companions advance — he rejoins them, his neck outstretched as if offered to the axe of fate.

"While these three men of Calais may be less brave than the three first, they do not deserve less admiration. For their devotion is even more meritorious, because it costs them more.

"So, in your *Burghers*, one follows the action,

more or less prompt, which was the outcome in each one of them according to his disposition of the authority and example of Eustache de Saint-Pierre. One sees them, gradually won by his influence, decide one after another to go forward with him to pay the price of their city.

"There, incontestably, is the best confirmation of your ideas on the scenic value of art."

"If your opinion of my work were not too high," Rodin answered, "I should acknowledge that you had perfectly understood my intentions. You have justly placed my burghers in the scale according to their degrees of heroism. To emphasize this effect still more I wished, as you perhaps know, to fix my statues one behind the other on the stones of the Place, before the Town Hall of Calais, like a living chaplet of suffering and of sacrifice.

"My figures would so have appeared to direct their steps from the municipal building toward the camp of Edward III.; and the people of Calais

of to-day, almost elbowing them, would have felt more deeply the tradition of solidarity which unites them to these heroes. It would have been, I believe, intensely impressive. But my proposal was rejected, and they insisted upon a pedestal which is as unsightly as it is unnecessary. They were wrong. I am sure of it."

"Alas," I said, "the artist has always to reckon with the routine of opinion, too happy if he can only realize a part of his beautiful dreams!"

CHAPTER V
DRAWING AND COLOR

CHAPTER V

DRAWING AND COLOR

RODIN has always drawn a great deal. He has sometimes used the pen, sometimes the pencil. Formerly he drew the outline with a pen, and then added the shading with a brush. These wash-drawings so executed looked as if made from bas-reliefs or from sculptured groups. They were purely the visions of a sculptor.

Later he used a lead pencil for his drawings from the nude, washing in the flesh tones in color. These drawings are freer than the first; the attitudes are less set, more fugitive. In them the touch seems sometimes almost frenzied — a whole body held in a single sweep of the pencil — and they betray the divine impatience of the artist who

93

fears that a fleeting impression may escape him. The coloring of the flesh is dashed on in three or four broad strokes, the modelling summarily produced by the drying of the pools of color where the brush in its haste has not paused to gather the drops left after each touch. These sketches fix the rapid gesture, the transient motion which the eye itself has hardly seized for one half second. They do not give you merely line and color; they give you movement and life. They are more the visions of a painter than of a sculptor.

Yet more recently Rodin, continuing to use the lead pencil, has ceased to model with the brush. He is now content to smudge in the contours with his finger. This rubbing produces a silvery gray which envelops the forms like a cloud, rendering them of almost unreal loveliness; it bathes them in poetry and mystery. These last studies I believe are the most beautiful. They are at once luminous, living, and full of charm.

As I was looking at some with Rodin, I said to

DRAWING AND COLOR

him how much they differed from the over-finished drawings which the public usually approve.

"It is true," he said, "that it is inexpressive minutiæ of execution and false nobility of gesture which please the ignorant. The crowd cannot understand a daring impression which passes over useless details to seize only upon the truth of the whole. It can understand nothing of that sincere observation which, disdaining theatrical poses, interests itself in the simple and much more touching attitudes of real life.

"It is difficult to correct the errors that prevail on the subject of drawing.

"It is a false idea that drawing in itself can be beautiful. It is only beautiful through the truths and the feelings that it translates. The crowd admires artists, who, strong in subject, elegantly pen contours destitute of significance, and who plant their figures in pretentious poses. It goes into ecstasies over poses which are never seen in nature, and which are considered artistic because

they recall the posturings of the Italian models who offer themselves at the studio door. That is what is generally called beautiful drawing. It is really only sleight-of-hand, fit to astonish boobies.

" Of course, there is drawing in art as there is style in literature. Style that is mannered, that strains after effect, is bad. No style is good except that which effaces itself in order to concentrate all the attention of the reader upon the subject treated, upon the emotion rendered.

" The artist who parades his drawing, the writer who wishes to attract praise to his style, resemble the soldier who plumes himself on his uniform but refuses to go into battle, or the farmer who polishes the ploughshare instead of driving it into the earth.

" You never think of praising either drawing or style which is truly beautiful, because you are carried away by the interest of all that they express. It is the same with color. There is really neither beautiful style, nor beautiful drawing, nor beautiful color; there is but one sole beauty, that of the

truth which is revealed. When a truth, when a profound idea, when a powerful feeling bursts forth in a great work, either literary or artistic, it is evident that the style, or the color and the drawing, are excellent; but these qualities exist only as the reflection of the truth.

" Raphael's drawing is admired—and justly—but it should not be admired only for itself, for its skilful balance of line; it should be admired for what it signifies. What forms all its merit is the sweet serenity of soul which saw with the eyes of Raphael and expressed itself with his hand, the love in him which seems to overflow from his heart upon all nature. Those who, lacking his soul, have sought to borrow the linear cadences and the attitudes of his figures, have never executed any but insipid imitations of the great master of Urbino.

" In the drawing of Michael Angelo it is not his manner, not the audacious foreshortening nor the skilful anatomy that should be admired, but the desperate force of the Titan. Those imitators who,

without his soul, have copied in their painting his buttressed attitudes and his tense muscles have made themselves ridiculous.

" In the color of Titian, what should be admired is not merely a more or less agreeable harmony, but the meaning that it offers. His color has no true beauty except as it conveys the idea of a sumptuous and dominant sovereignty.

" In the color of Veronese, the true beauty exists in its power to evoke in silvery play of color the elegant conviviality of patrician feasts.

" The color of Rubens is nothing in itself; its flaming wonder would be vain did it not give the impression of life, of joy, and of robust sensuousness.

" There does not perhaps exist a single work of art which owes its charm only to balance of line or tone, and which makes an appeal to the eyes alone. Take, for example, the stained-glass windows of the twelfth and thirteenth centuries — if they enchant us with the velvety depths of their blues, with the caress of their soft violets and their warm

crimsons, it is because their colors express the mystic joy which their pious creators hoped to win in the heaven of their dreams. If certain bits of Persian pottery, strewn with flowers of turquoise blue, are adorable marvels of color, it is because, in some strange manner, their exquisite shades transport the soul into I know not what valley of dreams and faëry. So, all drawing and all harmony of colors offer a meaning without which they would have no beauty."

"But do you not fear that disdain of craft in art —?" I broke in.

"Who speaks to you of disdaining it? Craft is only a means. But the artist who neglects it will never attain his end, which is the interpretation of feeling, of ideas. Such an artist would be like a horseman who forgot to give oats to his horse.

"It is only too evident that if drawing is lacking, if color is false, the most powerful emotion cannot find expression. Incorrect anatomy would raise a

laugh when the artist wished to be most touching.
Many young artists incur this disgrace to-day. As
they have never studied seriously, their unskilful-
ness betrays them at every turn. Their intentions
are good, but an arm which is too short, a leg
which is not straight, an inexact perspective, repels
the spectator.

"In short, no sudden inspiration can replace the
long toil which is indispensable to give the eyes a
true knowledge of form and of proportion and
to render the hand obedient to the commands of
feeling.

"And when I say that craft should be forgotten,
my idea is not for a moment that the artist can get
along without science. On the contrary, it is neces-
sary to have consummate technique in order to
hide what one knows. Doubtless, to the vulgar,
the jugglers who execute eccentric flourishes of
line, who accomplish astounding pyrotechnics of
color, or who write long phrases encrusted with
unusual words, are the most skilful men in the

world. But the great difficulty and the crown of art is to draw, to paint, to write with ease and simplicity.

" You see a picture, you read a page; you notice neither the drawing, the color, nor the style, but you are moved to the soul. Have no fear of making a mistake; the drawing, the color, the style are perfect in technique."

" Yet, Master, can it not happen that great and touching *chefs-d'œuvre* are wanting in technique? Is it not said, for instance, that Raphael's color is often bad and Rembrandt's drawing debatable? "

" It is wrong, believe me. If Raphael's masterpieces delight the soul, it is because everything in them, color as well as drawing, contributes to the enchantment. Look at the little *Saint George* in the Louvre, at the *Parnassus* in the Vatican, at the cartoons for the tapestry at South Kensington; the harmony in these works is charming. Sanzio's color is different from Rembrandt's, but it is exactly suited to his inspiration. It is clear

and enamelled. It offers fresh, flowery, joyous tonalities. It has the eternal youth of Raphael himself. It seems unreal, but only because the truth as observed by the master of Urbino is not that of purely material things; his is the domain of feeling, a region where forms and colors are transfigured by the light of love. Doubtless an out-and-out realist would call this coloring inexact; but a poet finds it true.

"What is certain is that the color of Rembrandt or of Rubens joined to Raphael's drawing would be ridiculous and monstrous, just as Rembrandt's drawing differs from that of Raphael, but is not less good. Raphael's lines are sweet and pure; Rembrandt's are often rude and jarring. The great Dutchman's vision was arrested by the roughness of garments, by the asperity of wrinkled faces, by the callousness of plebeian hands; for to Rembrandt beauty is only the antithesis between the triviality of the physical envelope and the inner radiance. How could he express this beauty composed of

apparent ugliness and moral grandeur if he tried
to rival Raphael in elegance? You must recognize
that his drawing is perfect because it corresponds
absolutely to the exigencies of his thought."

" So, according to you, it is an error to believe
that the same artist cannot be at once a great color-
ist and a great draughtsman? "

" Certainly, and I do not know how this idea has
become as firmly established as it seems to be. If
the great masters are eloquent, if they carry us
away, it is clearly because they possess exactly all
the means of expression that are necessary to them.
I have just proved it to you in the case of Raphael
and Rembrandt. The same demonstration could
be made in the case of all the great artists. For
instance, Delacroix has been accused of ignorance
of drawing. On the contrary, the truth is that his
drawing combines marvellously with his color; like
it, it is abrupt, feverish, exalted, it is full of vivac-
ity, of passion; like it, it is sometimes mad, and it
is then that it is the most beautiful. Color and

drawing, one cannot be admired without the other, for they are one.

"Where the demi-connoisseur deceives himself is in allowing for the existence of but one kind of drawing; that of Raphael, or perhaps it is not even that of Raphael, but that of his imitators, that of David or of Ingres. There are really as many kinds of drawing and of color as there are artists.

"Albrecht Dürer's color is called hard and dry. It is not so at all. But he is a German; he generalizes; his compositions are as exact as logical constructions; his people are as solid as essential types. That is why his drawing is so precise and his color so restrained.

"Holbein belongs to the same school. His drawing has none of the Florentine grace; his color has none of the Venetian charm; but his line and color have a power, a gravity, an inner meaning, which perhaps are found in no other painter.

"In general, it is possible to say that in artists as deliberate, as careful as these, drawing is par-

ticularly tight and the color is as cold as the verity of mathematics. In other artists, on the contrary, in those who are the poets of the heart, like Raphael, Correggio, Andrea del Sarto, line has more suppleness and color, more winning tenderness. In others whom we call *realists*, that is to say, whose sensibility is more exterior, in Rubens, Velasquez, Rembrandt, for example, line has a living charm with its force and its repose, and the color sometimes bursts into a fanfare of sunlight, sometimes fades into mist.

" So, the modes of expression of men of genius differ as much as their souls, and it is impossible to say that in some among them drawing and color are better or worse than in others."

" I understand, Master; but in refusing the usual classification of artists as draughtsmen or colorists, you do not stop to think how you embarrass the poor critics. Happily, however, it seems to me that in your words those who like categories may find a new method of classification. Color and drawing,

you say, are only means, and it is the soul of the artist that it is important to know. So painters should be grouped according to their dispositions. For example, Albrecht Dürer with Holbein — both are logicians. Raphael, Correggio, Andrea del Sarto, whom you have named together, make a class in which sentiment is predominant; they are in the front rank of the elegiacs. Another class would be composed of the masters who are interested in active existence, in daily life, and the trio of Rubens, Velasquez and Rembrandt would be its greatest constellation. Finally, artists such as Claude Lorraine and Turner, who considered nature as a tissue of brilliant and fugitive visions, would comprise a fourth group."

Rodin smiled. " Such a classification would not be wanting in ingenuity," he said, " and it would be much more just than that which divides the colorists from the draughtsmen.

" However, because of the complexity of art, or rather of the human souls who take art for a

language, all classification runs the risk of being futile. So Rembrandt is often a sublime poet and Raphael often a vigorous realist.

" Let us force ourselves to understand the masters — let us love them — let us go to them for inspiration; but let us refrain from labelling them like drugs in a chemist's shop."

CHAPTER VI
THE BEAUTY OF WOMEN

CHAPTER VI

THE BEAUTY OF WOMEN

THAT fine old house known as "l'Hôtel de Biron," which stands in a quiet street on the left bank of the Seine in Paris, and which was but lately the Convent of the Sacred Heart, has, since the suppression of the sisterhoods, been occupied by several tenants, among whom is Rodin.

The Master, as we have seen, has other ateliers at Meudon and at the Dépôt des Marbres in Paris, but he has a special liking for this one.

Built in the eighteenth century, the town house of a powerful family, it is certainly as beautiful a dwelling as any artist could desire. The great rooms are lofty, panelled in white, with beautiful mouldings in white and gold. The one in which

111

Rodin works is a rotunda opening by high French windows into a delightful garden.

For several years now this garden has been neglected. But it is still possible to trace, among the riotous weeds, the ancient lines of box which bordered the alleys, to follow, beneath fantastic vines, the shape of green trellised arbors; and there each spring the flowers reappear, pushing through the grasses in the borders. Nothing induces a more delicious melancholy than this spectacle of the gradual effacement of human toil at the hands of invading nature.

At l'Hôtel de Biron Rodin passes nearly all his time in drawing.

In this quiet retreat he loves to isolate himself and to consign to paper, in numberless pencil sketches, the graceful attitudes which his models take before him.

One evening I was looking over a series of these studies with him, and was admiring the harmonious lines by which he had repro-

duced all the rhythm of the human body upon paper.

The outlines, dashed in with a single stroke, evoked the fire or the *abandon* of the movements, and his thumb had interpreted by a very slight shade the charm of the modelling. As he studied the drawings he seemed to see again in mind the models who were their originals. He constantly exclaimed:

" Ah! this one's shoulders, what a delight! A curve of perfect beauty! My drawing is too heavy! I tried indeed, but —! See, here is a second attempt from the same woman. This is more like her. And yet!

" And just look at this one's throat, the adorable elegance of this swelling line, it has an almost intangible grace!

" Master," I asked, " is it easy to find good models? "

" Yes."

" Then beauty is not very rare in France? "

THE BEAUTY OF WOMEN

" No, I tell you."

" But tell me, do you not think that the beauty of the antique much surpassed that of our day, and that modern women are far from equalling those who posed for Phidias?'

" Not at all."

" Yet the perfection of the Greek Venuses — "

" The artists in those days had eyes to see, while those of to-day are blind; that is all the difference. The Greek women were beautiful, but their beauty lived above all in the minds of the sculptors who carved them.

" To-day there are women just like them. They are principally in the South of Europe. The modern Italians, for example, belong to the same Mediterranean type as the models of Phidias. This type has for its special characteristic the equal width of shoulders and hips."

" But did not the invasion of the barbarians by a mixture of race alter the standard of antique beauty?"

THE BEAUTY OF WOMEN

" No. Even if we suppose that the barbarians
were less beautiful, less well-proportioned than the
Mediterranean race, which is possible, time has
effectually wiped out any stains produced by a
mixed blood, and has again produced the harmony
of the ancient type. In a union of the beautiful
and the ugly, it is always the beautiful which tri-
umphs in the end. Nature, by a Divine law, tends
constantly towards the best, tends ceaselessly
towards perfection. Besides the Mediterranean
type, there exists a Northern type, to which many
Frenchwomen, as well as the women of the Ger-
manic and Slavic races, belong. In this type the
hips are strongly developed and the shoulders are
narrower; it is this structure that you observe, for
example, in the nymphs of Jean Goujon, in the
Venus of the *Judgment of Paris* by Watteau, and
in the *Diana* by Houdon. In this type, too, the
chest is generally high, while in the antique and
Mediterranean types the thorax is, on the contrary,
straight. To tell the truth, every human type,

every race, has its beauty. The thing is to discover it. I have drawn with infinite pleasure the little Cambodian dancers who lately came to Paris with their sovereign. The fine, small gestures of their graceful limbs had a strange and marvellous beauty.

"I have made studies of the Japanese actress Hanako. Her muscles stand out as prominently as those of a fox-terrier; her sinews are so developed that the joints to which they are attached have a thickness equal to the members themselves. She is so strong that she can rest as long as she pleases on one leg, the other raised at right angles in front of her. She looks as if rooted in the ground, like a tree. Her anatomy is quite different from that of a European, but, nevertheless, very beautiful in its singular power."

An instant later, returning to the idea which is so dear to him, he said: "In short, Beauty is everywhere. It is not she that is lacking to our eye, but our eyes which fail to perceive her. Beauty

is character and expression. Well, there is nothing in nature which has more character than the human body. In its strength and its grace it evokes the most varied images. One moment it resembles a flower: the bending torso is the stalk; the breasts, the head, and the splendor of the hair answer to the blossoming of the corolla. The next moment it recalls the pliant creeper, or the proud and upright sapling. 'In seeing you,' says Ulysses to Nausicaa, 'I seem to see a certain palm-tree which at Delos, near the altar of Apollo, rose from earth to heaven in a single shoot.' Again, the human body bent backwards is like a spring, like a beautiful bow upon which Eros adjusts his invisible arrows. At another time it is an urn. I have often asked a model to sit on the ground with her back to me, her arms and legs gathered in front of her. In this position the back, which tapers to the waist and swells at the hips, appears like a vase of exquisite outline.

"The human body is, above all, the mirror of

the soul, and from the soul comes its greatest beauty.

" ' Chair de la femme, argile idéale, o merveille,
 O pénétration sublime de l'esprit
 Dans le limon que l'Etre ineffable petrit.
 Matière où l'âme brille à travers son suaire.
 Boue où l'on voit les doigts du divine statuaire.
 Fange auguste appelant les baisers et le cœur.
 Si sainte qu'en ne sait, tant l'amour est vainqueur
 Tant l'âme est, vers ce lit mystérieux, poussée.
 Si cette volupté n'est pas une pensée.
 Et qu'on ne peut, à l'heure où les sens sont en feu.
 Etreindre la Beauté sans croire embrasser Dieu! ' [1]

" Yes, Victor Hugo understood! What we adore in the human body more even than its beautiful form is the inner flame which seems to shine from within and to illumine it."

[1] See page 250.

CHAPTER VII
OF YESTERDAY AND OF TO-DAY

CHAPTER VII

OF YESTERDAY AND OF TO-DAY

A FEW days ago I accompanied Auguste Rodin, who was on his way to the Louvre, to see once again the busts by Houdon.

We were no sooner in front of the bust of Voltaire than the Master cried:

"What a marvel it is! It is the personification of malice. See! his sidelong glance seems watching some adversary. He has the pointed nose of a fox; it seems smelling out from side to side for abuses and follies. You can see it quiver! And the mouth — what a triumph! It is framed by two furrows of irony. It seems to mumble sarcasms.

"A cunning old gossip — that is the impression produced by this Voltaire, at once so lively, so sickly, and so little masculine."

After a moment of contemplation he continued:
" The eyes! I always come back to them. They
are transparent. They are luminous.

" But you can say as much of all busts by Hou-
don. This sculptor understood how to render the
transparency of the pupils better than any painter
or pastellist. He perforated them, bored them, cut
them out; he cleverly raised a certain unevenness
in them which, catching or losing the light, gives
a singular effect and imitates the sparkle of life
in the pupil. And what diversity in the expression
of the eyes of all these faces! Cunning in Voltaire,
good fellowship in Franklin, authority in Mira-
beau, gravity in Washington, joyous tenderness in
Madame Houdon, roguishness in his daughter and
in the two charming little Brongniart children. To
this sculptor the glance is more than half the ex-
pression. Through the eyes he read souls. They
kept no secrets from him. So there is no need to
ask if his busts were good likenesses."

At that word I stopped Rodin. " You consider,

then, that resemblance is a very important quality?"

"Certainly; indispensable."

"Yet many artists say that busts and portraits can be very fine without being good likenesses. I remember a remark on this subject attributed to Henner. A lady complained to him that the portrait which he had painted of her did not look like her.

"'Hé! Matame,' he replied in his Alsatian jargon, 'when you are dead your heirs will think themselves fortunate to possess a fine portrait by Henner and will trouble themselves very little to know if it was like you or not.'"

"It is possible that the painter said that," Rodin answered, "but it was doubtless a sally which did not represent his real thought, for I do not believe that he had such false ideas in an art in which he showed great talent.

"But first let us understand the kind of resemblance demanded in a bust or portrait.

"If the artist only reproduces superficial features as photography does, if he copies the lineaments of a face exactly, without reference to character, he deserves no admiration. The resemblance which he ought to obtain is that of the soul; that alone matters; it is that which the sculptor or painter should seek beneath the mask of features.

"In a word, all the features must be expressive — that is to say, of use in the revelation of a conscience."

"But does n't it sometimes happen that the face contradicts the soul?"

"Never."

"Have you forgotten the precept of La Fontaine, 'Il ne faut point juger les gens sur l'apparence'?"

"That maxim is only addressed to superficial observers. For appearances may deceive their hasty examination. La Fontaine writes that the little mouse took the cat for the kindest of creatures,

but he speaks of a little mouse — that is to say, of a scatterbrain who lacked critical faculty. The appearance of a cat would warn whoever studied it attentively that there was cruelty hidden under that sleepiness. A physiognomist can easily distinguish between a cajoling air and one of real kindness, and it is precisely the rôle of the artist to show the truth, even beneath dissimulation.

"To tell the truth, there is no artistic work which requires as much penetration as the bust and the portrait. It is sometimes said the artist's profession demands more manual skill than intelligence. You have only to study a good bust to correct this error. Such a work is worth a whole biography. Houdon's busts, for example, are like chapters of written memoirs. Period, race, profession, personal character — all are indicated there.

"Here is Rousseau opposite Voltaire. Great shrewdness in his glance. It is the quality common to all the personages of the eighteenth century; they are critics; they question all the prin-

ciples which were unquestioningly accepted before; they have searching eyes.

"Now for his origin. He is the Swiss plebeian. Rousseau is as unpolished, almost vulgar, as Voltaire is aristocratic and distinguished. Prominent cheekbones, short nose, square chin — you recognize the son of the watchmaker and the whilom domestic.

"Profession now: he is the philosopher; sloping, thoughtful forehead, antique type accentuated by the classic band about his head. Appearance purposely wild, hair neglected, a certain resemblance to some Diogenes or Menippus; this is the preacher of the return to nature and to the primitive life.

"Individual character: a general contraction of the face; this is the misanthrope. Eyebrows contracted, forehead lined with care; this is the man who complains, often with reason, of persecution.

"I ask you if this is not a better commentary on the man than his *Confessions?*

OF YESTERDAY AND OF TO-DAY

"Now Mirabeau. Period; challenging attitude, wig disarranged, dress careless; a breath of the revolutionary tempest passes over this wild beast, who is ready to roar an answer.

"Origin; dominating aspect, fine arched eyebrows, haughty forehead; this is the former aristocrat. But the democratic heaviness of the pockmarked cheeks and of the neck sunk between the shoulders betrays the Count de Riquetti to the sympathies of Thiers, whose interpreter he has become.

"Profession: the tribune. The mouth protrudes like a speaking-trumpet ready to fling his voice abroad. He lifts his head because, like most orators, he was short. In this type of man nature develops the chest, the barrel, at the expense of height. The eyes are not fixed on any one; they rove over a great assembly. It is a glance at once vague and superb. Tell me, is it not a marvellous achievement to evoke in this one head a whole crowd — more, a whole listening country?

"Finally, the individual character. Observe the

sensuous lips, the double chin, the quivering nostrils; you will recognize the faults — habit of debauch and demand for enjoyment. All is there, I tell you.

"It would be easy to sketch the same character outline from all the busts of Houdon.

"Here, again, is Franklin. A ponderous air, heavy falling cheeks; this is the former artisan. The long hair of the apostle, a kindly benevolence; this is the popular moralizer, good-natured Richard.

"A stubborn high forehead inclined forward, indicative of the obstinacy of which Franklin gave proof in winning an education, in rising, in becoming an eminent scholar, finally in freeing his country. Astuteness in the eyes and in the corners of the mouth; Houdon was not duped by the general massiveness, and he divined the prudent materialism of the calculator who made a fortune, and the cunning of the diplomat who wormed out the secrets of English politics. Here, living, is one of the ancestors of modern America!

"Well! Here, in these remarkable busts, do we not find the fragmentary chronicle of half a century? And, as in the finest written narratives, what pleases most in these memoirs in terra-cotta, in marble and in bronze, is the brilliant grace of the style, the lightness of the hand that wrote them, the generosity of this charming personality, so essentially French, who created them. Houdon is Saint-Simon without his aristocratic prejudices; is Saint-Simon as witty but more magnanimous. Ah! what a divine artist!"

"It must be very difficult," I said, verifying in the busts before us the interpretation of my companion, "to penetrate so profoundly into the consciousness of others."

"Yes, doubtless." Then, with a shade of irony, "But the greatest difficulties for the artist who models a bust or who paints a portrait do not come from the work which he executes. They come from the client for whom he works. By a strange and fatal law, the one who orders his own likeness

is the one who always desperately combats the talent of the artist he has chosen. It is very seldom that a man sees himself as he is, and even if he knows himself, he does not wish the artist to represent him as he is. He asks to be represented under the most banal and neutral aspect. He wishes to be an official or worldly marionette. It pleases him to have the function he exercises, the rank he holds in society, completely efface the man that is in him. The magistrate wishes his robe, the general his gold-laced tunic. They care very little whether one can read their characters.

" This explains the success of so many mediocre painters and sculptors who are satisfied to give the impersonal appearance of their clients: their gold lace and their official attitude. These are the artists who are generally highest in favor because they lend their models a mask of riches and importance. The more bombastic a portrait is, the more it resembles a stiff, pretentious doll, the better the client is satisfied.

" Perhaps it was not always so.

" Certain seigneurs of the fifteenth century, for example, seem to have been pleased to see themselves portrayed as hyenas or vultures on the medals of Pisanello. They were doubtless proud of their individuality. Or, better still, they loved and venerated art, and they accepted the rude frankness of the artist, as though it were a penance imposed by a spiritual director.

" Titian did not hesitate to give Pope Paul III. a marten's snout, nor to emphasize the domineering hardness of Charles V., or the salaciousness of Francis I., and it does not appear to have damaged his reputation with them. Velasquez, who portrayed King Philip IV. as a nonentity, though an elegant man, and who unflatteringly reproduced his hanging jaw, nevertheless kept his favor. And the Spanish monarch has acquired from posterity the great glory of having been the protector of genius.

" But the men of to-day are so made that they

fear truth and love a lie. They seem to be displeased to appear in their busts as they are. They all want to have the air of hairdressers.

" And even the most beautiful women, that is to say, those whose lines have most style, are horrified at their own beauty when a sculptor of talent is its interpreter. They beseech him to make them ugly by giving them an insignificant and doll-like physiognomy.

" So, to execute a bust is to fight a long battle. The one thing that matters is not to weaken and to rest honest with one's self. If the work is refused, so much the worse. So much the better perhaps; for often, it proves that it is full of merit.

" As for the client who, though discontented, accepts a successful work, his bad humor is only temporary; for soon the connoisseurs compliment him on the bust and he ends by admiring it. Then he declares quite naturally that he has always liked it.

"Moreover, it should be noticed that the busts which are executed gratuitously for friends or relations are the best. It is not only because the artist knows his models better from seeing them constantly and loving them. It is, above all, because the gratuitousness of his work confers on him the liberty of working as he pleases.

"Nevertheless, the best busts are often refused, even when offered as gifts. Though masterpieces, they are considered insulting by those for whom they are intended. The sculptor must go his own way and find all his pleasure, all his reward, in doing his best."

I was much interested in this psychology of the public with which the artist has to deal; but it must be said that a good deal of bitterness entered into Rodin's irony.

"Master," I said, "among the trials of your profession, there is one that you seem to have omitted. That is, to do the bust of a client whose head is without expression or betrays obvious stupidity."

Rodin laughed. "That cannot count among the trials," he replied. "You must not forget my favorite maxim: *Nature is always beautiful.* We need only to understand what she shows us. You speak of a face without expression. There is no such face to an artist. To him every head is interesting. Let a sculptor note the insipidity of a face, let him show us a fool absorbed by his care of worldly parade, and there we have a fine bust.

"Besides, what is called shallowness is often only a conscience which has not developed owing to a lack of education, and in that case, the face offers the mysterious and fascinating spectacle of an intellect which seems enveloped in a veil.

"Finally — how shall I put it? — even the most insignificant head is the dwelling-place of life, that magnificent force, and so offers inexhaustible matter for the masterpiece."

Several days later I saw in Rodin's atelier at Meudon the casts of many of his finest busts, and

OF YESTERDAY AND OF TO-DAY

I seized the occasion to ask him to tell me of the memories they recalled.

His *Victor Hugo* was there, deep in meditation, the forehead strangely furrowed, volcanic, the hair wild, almost like white flames bursting from his skull. It was the very personification of modern lyricism, profound and tumultuous.

" It was my friend Bazire," said Rodin, " who presented me to Victor Hugo. Bazire was the secretary of the newspaper, *La Marseillaise*, and later of *l'Intransigeant*. He adored Victor Hugo. It was he who started the idea of a public celebration of the great man's eightieth birthday.

" The celebration, as you know, was both solemn and touching. The poet from his balcony saluted an immense crowd who had come before his house to acclaim him; he seemed a patriarch blessing his family. Because of that day, he kept a tender gratitude for the man who had arranged it. And that was how Bazire introduced me to his presence without difficulty.

135

OF YESTERDAY AND OF TO-DAY

"Unfortunately, Victor Hugo had just been martyred by a mediocre sculptor named Villain, who, to make a bad bust, had insisted on thirty-eight sittings. So when I timidly expressed my desire to reproduce the features of the author of *Contemplation*, he knit his Olympian brows.

"'I cannot prevent your working,' he said, 'but I warn you that I will not pose. I will not change one of my habits on your account. Make what arrangements you like.'

"So I came and I made a great number of flying pencil notes to facilitate my work of modelling later. Then I brought my stand and some clay. But naturally I could only install this untidy paraphernalia in the veranda, and as Victor Hugo was generally in the drawing-room with his friends, you may imagine the difficulty of my task. I would study the great poet attentively, and endeavor to impress his image on my memory; then suddenly with a run I would reach the veranda to fix in clay the memory of what I had just seen. But

136

often, on the way, my impression had weakened, so that when I arrived before my stand I dared not touch the clay, and I had to resolve to return to my model again.

"When I had nearly finished my work, Dalou asked me to introduce him to Victor Hugo, and I willingly rendered him this service, but the glorious old man died soon after, and Dalou could only do his best from a cast taken after death."

Rodin led me as he spoke to a glass case which enclosed a singular block of stone. It was the keystone of an arch, the stone which the architect sets in the centre to sustain the curve. On the face of this stone was carved a mask, squared along the cheeks and temples, following the shape of the block. I recognized the face of Victor Hugo.

"I always imagine this the keystone at the entrance of a building dedicated to poetry," said the master sculptor.

I could easily fancy it. The brow of Victor Hugo thus supporting the weight of a monumental

arch would symbolize the genius on which all the thought and all the activity of an epoch had rested.

"I give this idea to any architect who will put it into execution," Rodin added.

Close by stood the cast of the bust of Henri Rochefort. It is well known; the head of an insurgent, the forehead as full of bumps as that of a pugnacious child who is always fighting his companions, the wild tuft of hair which seems to wave like a signal for mutiny, the mouth twisted by irony, the mad beard; a continual revolt, the very spirit of criticism and combativeness. Admirable work it is, in which one sees one side of our contemporary mentality reflected.

"It was also through Bazire," said Rodin, "that I made the acquaintance of Henri Rochefort, who was editor-in-chief of his newspaper. The celebrated polemic consented to pose to me. He had such a joyous spirit that it was an enchantment to listen to him, but he could not keep still for a single instant. He reproached me pleasantly for having

138

too much professional conscience. He said laughingly that I spent one sitting in adding a lump of clay to the model and the next in taking it away.

"When, some time after, his bust received the approbation of men of taste, he joined unreservedly in their praises, but he would never believe that my work had remained exactly as it was when I took it away from his house. 'You have retouched it very much,' he would repeat. In reality, I had not even touched it with my nail."

Rodin, placing one of his hands over the tuft of hair and the other over the beard, then asked me, "What impression does it make now?"

"You would say it was a Roman emperor."

"That is just what I wanted to make you say. I have never found the Latin classic type as pure as in Rochefort."

If this ancient enemy of the Empire does not yet know this paradoxical resemblance of his profile to that of the Cæsars, I wager that it will make him smile.

OF YESTERDAY AND OF TO-DAY

When Rodin, a moment before, had spoken of Dalou, I had seen in thought his bust of this sculptor which is at the Luxembourg. It is a proud, challenging head, with the thin, sinewy neck of a child of the faubourgs, the bristly beard of an artisan, a contracted forehead, the wild eyebrows of an ancient communist, and the feverish and haughty air of the irreducible democrat. For the rest, the large fine eyes and the delicate incurvation of the temples reveal the passionate lover of beauty.

In answer to a question, Rodin replied that he had modelled this bust at a moment when Dalou, profiting by the amnesty, had returned from England.

" He never took it away," he said, " for our relations ended just after I had introduced him to Victor Hugo.

" Dalou was a great artist, and many of his works have a superb decorative value which allies them to the most beautiful groups of our seventeenth century.

OF YESTERDAY AND OF TO-DAY

" If he had not had the weakness to desire an
official position he would never have produced any-
thing but masterpieces. But he aspired to become
the Le Brun of our Republic and the leader of all
our contemporary artists. He died before he suc-
ceeded in his ambition.

" It is impossible to exercise two professions at
once. All the activity that is expended in acquir-
ing useful relations and in playing a rôle is lost
to art. Intriguers are not fools; when an artist
wishes to compete with them he must expend as
much effort as they do, and he will have hardly
any time left for work.

" Who knows? If Dalou had always stayed in
his atelier peacefully pursuing his calling, he
would have without doubt brought forth marvels
whose beauty would have astonished all eyes, and
common consent would have perhaps awarded him
that artistic sovereignty to whose conquest he un-
successfully used all his skill.

" His ambition, however, was not entirely vain,

141

for his influence at the Hôtel de Ville gave us one of the great masterpieces of our time. It was he who, in spite of the undisguised hostility of the administrative committee, gave the order to Puvis de Chavannes for the decoration of the stairway at the Hôtel de Ville. And you know with what heavenly poetry the great painter illuminated the walls of the municipal building."

These words called attention to the bust of Puvis de Chavannes.

" He carried his head high," Rodin said. " His skull, solid and round, seemed made to wear a helmet. His arched chest seemed accustomed to carry the breastplate. It was easy to imagine him at Pavia fighting for his honor by the side of Francis I."

In the bust you recognize the aristocracy of an old race. The high forehead and eyebrows reveal the philosopher, and the calm glance, embracing a wide outlook, betrays the great decorator, the sublime landscapist. There is no modern artist for

142

whom Rodin professes more admiration, more profound respect, than for the painter of *Sainte-Geneviève*.

" To think that he has lived among us," he cries; " to think that this genius, worthy of the most radiant epochs of art, has spoken to us! That I have seen him, have pressed his hand! It seems as if I had pressed the hand of Nicolas Poussin!"

What a charming remark! To put the figure of a contemporary back into the past, in order to range it there by one of those who shine brightest, and then to be so moved at the very thought of physical contact with this demi-god — could any homage be more touching?

Rodin continued: " Puvis de Chavannes did not like my bust of him, and it was one of the bitter things of my career. He thought that I had caricatured him. And yet I am certain that I have expressed in my sculpture all the enthusiasm and veneration that I felt for him."

The bust of Puvis made me think of that

of Jean-Paul Laurens, which is also in the Luxembourg.

A round head, the face mobile, enthusiastic, almost breathless — this is a Southerner — something archaic and rude in the expression — eyes which seem haunted by distant visions — it is the painter of half-savage epochs, when men were robust and impetuous.

Rodin said: "Laurens is one of my oldest friends. I posed for one of the Merovingian warriors who, in the decoration of the Pantheon, assist at the death of Sainte-Geneviève. His affection for me has always been faithful. It was he who got me the order for the *Bourgeois de Calais*. Though it did not bring me much, because I delivered six figures in bronze for the price they offered me for one, yet I owe him profound gratitude for having spurred me to the creation of one of my best works.

"It was a great pleasure to me to do his bust. He reproached me in a friendly way for having

done him with his mouth open. I replied that, from the design of his skull, he was probably descended from the ancient Visigoths of Spain, and that this type was characterized by the prominence of the lower jaw. But I do not know whether he agreed to the justice of this ethnographical observation."

At this moment I perceived a bust of Falguière. Fiery, eruptive character, his face sown with wrinkles and bumps like a land ravaged by storms, the moustaches of a grumbler, hair thick and short.

" He was a little bull," said Rodin.

I noted the thickness of the neck, where the folds of skin almost formed a dewlap, the square of forehead, the head bent and obstinate, ready for a forward plunge. A little bull! Rodin often makes these comparisons with the animal kingdom. Such a one, with his long neck and automatic gestures, is a bird which pilfers right and left; such another, too amiable, too coquettish,

145

is a King Charles spaniel, and so on. These comparisons evidently facilitate the work of the mind which seeks to class all physiognomies in general categories.

Rodin told me under what circumstances he knew Falguière.

" It was," he said, " when the Société des Gens de Lettres refused my Balzac. Falguière, to whom the order was then given, insisted on showing me, by his friendship, that he did not at all agree with my detractors. Actuated by sympathy I offered to do his bust. He considered it a great success when it was finished — he even defended it, I know, against those who criticised it in his presence; and, in his turn, he did my bust, which is very fine."

As I was turning away I caught sight of a copy in bronze of the bust of Berthelot. Rodin made it only a year before the death of the great chemist. The great scholar rests in the knowledge of his work accomplished. He meditates. He is

146

alone, face to face with himself; alone, face to face with the crumbling of ancient faiths; alone before nature, some of whose secrets he has penetrated, but which remains so immensely mysterious; alone at the edge of the infinite abyss of the skies; and his tormented brow, his lowered eyes, are filled with melancholy. This fine head is like the emblem of modern intelligence, which, satiated with knowledge, weary of thought, ends by demanding " What is the use? "

All the busts which I had been admiring and about which my host had been talking now grouped themselves in my mind, and they appeared to me as a rich treasure of documents upon our epoch.

" If Houdon," I said, " has written memoirs of the eighteenth century, you have written those of the end of the nineteenth. Your style is more harsh, more violent than that of your predecessor, your expressions are less elegant, but more natural and more dramatic, if I may say so.

" The scepticism which in the eighteenth century

147

was distinguished and full of raillery has become, in you, rough and sharp. Houdon's people were more sociable, yours are more self-centred. Those of Houdon criticised the abuses of a *régime,* yours seem to question the value of human life itself and to feel the anguish of unrealized desires."

Rodin answered, " I have done my best. I have not lied; I have never flattered my contemporaries. My busts have often displeased because they were always very sincere. They certainly have one merit — veracity. Let it serve them for beauty! "

CHAPTER VIII
THOUGHT IN ART

CHAPTER VIII

THOUGHT IN ART

ONE morning, finding myself with Rodin in his atelier, I stopped before the cast of one of his most impressive works.

It is a young woman whose writhing body seems a prey to some mysterious torment. Her head is bent low, her lips and her eyes are closed, and you would think she slept, did not the anguish in her face betray the conflict of her spirit. The most surprising thing in the figure, however, is that it has neither arms nor legs. It would seem that the sculptor in a moment of discontent with himself had broken them off, and you cannot help regretting that the figure is incomplete. I could not refrain from expressing this feeling to my host.

THOUGHT IN ART

" What do you mean? " he cried in astonishment. "Don't you see that I left it in that state intentionally? My figure represents *Meditation*. That's why it has neither arms to act nor legs to walk. Haven't you noticed that reflection, when persisted in, suggests so many plausible arguments for opposite decisions that it ends in inertia? "

These words corrected my first impression and I could unreservedly admire the fine symbolism of the figure. I now understood that this woman was the emblem of human intelligence assailed by problems that it cannot solve, haunted by an ideal that it cannot realize, obsessed by the infinite which it can never grasp. The straining of this body marked the travail of thought and its glorious, but vain determination to penetrate those questions which it cannot answer; and the mutilation of its members indicated the insurmountable disgust which contemplative souls feel for actual life.

Nevertheless, this figure recalled a criticism
152

which is often heard on Rodin's works, and, though without agreeing with it, I submitted it to the Master to find out how he would answer it.

"Literary people," I said, "always praise the essential truths expressed in your sculptures. But certain of your censors blame you precisely for having an inspiration which is more literary than plastic. They pretend that you easily win the approbation of writers by providing them with subjects which offer an opening for all their rhetoric. And they declare that art is not the place for so much philosophic ambition."

"If my modelling is bad," Rodin replied sharply, "if I make faults in anatomy, if I misinterpret movement, if I am ignorant of the science which animates marble, the critics are right a hundred times. But if my figures are correct and full of life, with what can they reproach me? What right have they to forbid me to add meaning to form? How can they complain if, over and above technique, I offer them ideas? — if I enrich those forms

153

which please the eye with a definite significance?
It is a strange mistake, this, to imagine that the
true artist can be content to remain only a skilled
workman and that he needs no intelligence. On
the contrary, intelligence is indispensable to him
for painting and for carving even those figures
which seem most lacking in spiritual pretensions
and which are only meant to charm the eye. When
a good sculptor models a statue, whatever it is, he
must first clearly conceive the general idea; then,
until his task is ended, he must keep this idea of
the whole in his mind in order to subordinate and
ally to it every smallest detail of his work. And
this is not accomplished without an intense effort
of mind and concentration of thought.

"What has doubtless led to the common idea
that artists have little intelligence is that it seems
lacking in many of them in private life. The biog-
raphies of painters and sculptors abound in anec-
dotes of the simplicity of certain masters. It must
be admitted that great men who think ceaselessly

of their work are frequently absent-minded in daily life. Above all, it must be granted that many very intelligent artists seem narrow because they have not that facility of speech and repartee which, to superficial observers, is the only sign of cleverness."

"Surely," I said, "no one can contest the mental vigor of the great painters and sculptors. But, to return to our question — is there not a sharp line dividing art from literature which the artist should not cross?"

"I insist that in matters which concern me I cannot stand these limitations," Rodin answered. "There is no rule, according to my idea, that can prevent a sculptor from creating a beautiful work.

"What difference does it make whether it is sculpture or literature, provided the public find profit and pleasure in it? Painting, sculpture, literature, music are more closely related than is generally believed. They express all the sentiments of the human soul in the light of nature. It is only the means of expression which vary.

THOUGHT IN ART

"But if a sculptor, by the means of his art, succeeds in suggesting impressions which are ordinarily only procured by literature or music, why should the world cavil? A publicist lately criticised my *Victor Hugo* in the Palais Royal, declaring that it was not sculpture, but music. And he naïvely added that this work reminded him of a Beethoven symphony. Would to Heaven that it were true!

"I do not deny, moreover, that it is useful to reflect upon the differences which separate literary from artistic methods. First of all, literature offers the peculiarity of being able to express ideas without recourse to imagery. For example, it can say: *Profound reflection often ends in inaction,* without the necessity of figuring a thoughtful woman held in a block of stone.

"And this faculty of juggling with abstractions by means of words gives, perhaps, to literature an advantage over other arts in the domain of thought.

THOUGHT IN ART

" The next thing to be noticed is that literature develops stories which have a beginning, a middle, and an end. It strings together different events from which it draws a conclusion. It makes people act and shows the consequences of their conduct. So the scenes that it conjures up gain strength by their sequence, and even have no value except as they make part of the progress of a plot.

" It is not the same with the arts of form. They never represent more than a single phase of an action. That is why painters and sculptors are wrong in taking subjects from writers, as they often do. The artist who interprets a part of a story may be supposed to know the rest of the text. His work must prop itself up on that of the writer; it only acquires all its meaning if it is illuminated by the facts that precede or follow it.

" When the painter Delaroche represents, after Shakespeare, or after his pale imitator, Casimir Delavigne, the *Children of Edward* (*les Enfants*

d'Edouard) clinging to each other, it is necessary to know, in order to be interested, that they are the heirs to a throne, that they have been imprisoned, and that hired murderers, sent by the usurper, are just coming to assassinate them.

"When Delacroix, that genius whose pardon I beg for citing him next to the very mediocre Delaroche, takes from Lord Byron's poem the subject of *Don Juan's Shipwreck* (*Naufrage de Don Juan*) and shows us a boat in a storm-swept sea, where the sailors are engaged in drawing bits of paper from a hat, it is necessary, in order to understand this scene, to know that these unhappy creatures are starving and are drawing lots to see which of them shall serve as food for the others.

"These two artists, in treating literary subjects, commit the fault of painting pictures which do not carry in themselves their complete meaning.

"Yet, while that of Delaroche is bad because the drawing is cold, the color hard, the feeling melodramatic, that of Delacroix is admirable be-

cause this boat really pitches on the glaucous waves, because hunger and distress convulse the faces of the shipwrecked, because the sombre fury of the coloring announces some horrible crime — because, in short, if Byron's tale is found mutilated in the picture, in revenge, the fiery, wild, and sublime soul of the painter is certainly wholly there.

" The moral of these two examples is this; when, after mature reflection, you have laid down prohibitions which seem most reasonable in the matter of art, you will rightly reproach the mediocre man because he does not submit to them, but you will be surprised to observe that the man of genius infringes them almost with impunity."

Roving round the atelier while Rodin was talking, my eyes found a cast of his *Ugolino*.

It is a figure of majestic realism. It does not at all recall Carpeaux's group; if possible, it is even more pathetic. In Carpeaux's work, the Pisan count, tortured by madness, hunger, and

sorrow at the sight of his dying children, gnaws his two fists. Rodin has pictured the drama further advanced. The children of Ugolin are dead; they lie on the ground, and their father, whom the pangs of hunger have changed into a beast, drags himself on his hands and knees above their bodies. He bends above their flesh — but, at the same time, he turns away his head. There is a fearful contest within him between the brute seeking food and the thinking being, the loving being, who has a horror of this monstrous sacrifice. Nothing could be more poignant.

" There," said I, " is an example to add to that of the shipwreck in confirmation of your words; it is certain that it is necessary to have read the *Divine Comedy* in order to represent the circumstances of Ugolin's torment — but even if the stanzas of Dante were unknown, it would be impossible to remain unmoved before the terrible inner conflict which is expressed in the attitude and the features of your figure."

THOUGHT IN ART

"It is true," Rodin added, "when a literary subject is so well known the artist can treat it and yet expect to be understood. Yet it is better, in my opinion, that the works of painters and sculptors should contain all their interest in themselves. Art can offer thought and imagination without recourse to literature. Instead of illustrating scenes from poems, it need only use plain symbols which do not require any written text. Such has generally been my own method."

What my host indicated, his sculptures gathered around us proclaimed in their mute language. There I saw the casts of several of his works which are most full of ideas.

I began to study them one by one.

I admired the reproduction of the *Pensée*, which is at the Musée du Luxembourg. Who does not recall this singular work?

It is the head of a woman, very young, very fine, with features of miraculous subtlety and delicacy. Her head is bent and aureoled with a rev-

erie which makes it appear almost immaterial. The edges of a light coif which shadow her forehead seem the wings of her dreams. But her neck and even her chin are still held in the heavy, massive block of marble from which they cannot get free.

The symbol is easily understood. Thought expands within the breast of inert matter, and illumines it with the reflection of her splendor — but she vainly endeavors to escape from the heavy shackles of reality.

Next I turned to *Illusion, daughter of Icarus* (*l'Illusion, fille d'Icare*). It is the figure of a youthful angel. As she flew with her great wings through space, a rude blast of wind dashed her to earth, and her charming face was crushed against a rock. But her wings, unbroken, still beat the air, and, immortal, she will rise again, take flight again, fall again to earth, and this to the end of time. Untiring hopes, eternal disappointments of illusion!

Now my attention was attracted by a third

sculpture, the *Centauress*. The human bust of the fabulous creature yearns despairingly towards an end which her longing arms can never attain; but the hind hoofs, grappling the soil, are fast there, and the heavy horse's flanks, almost crouched in the mud, cannot kick free. It is the frightful opposition of the poor monster's two natures — an image of the soul, whose heavenly impulses rest miserably captive to the bodily clay.

" In themes of this kind," Rodin said, " the thought, I believe, is easily read. They awaken the imagination of the spectators without any outside help. And yet, far from confining it in narrow limits, they give it rein to roam at will. That is, according to me, the rôle of art. The form which it creates ought only to furnish a pretext for the unlimited development of emotion."

At this instant I found myself before a group in marble representing Pygmalion and his statue. The sculptor passionately embraces his work, which awakes to life within his arms.

"I am going to surprise you," said Rodin, suddenly; "I will show you the first sketch for this composition," and he led me towards a plaster cast.

I was indeed surprised. This had nothing whatever to do with the story of Pygmalion. It was a faun, horned and hairy, who clutched a panting nymph. The general lines were about the same, but the subject was very different. Rodin seemed amused at my silent astonishment.

This revelation was somewhat disconcerting to me; for, contrary to all that I had just heard and seen, my host proved himself indifferent, in certain cases, to the subject. He watched me keenly.

"To sum it up," he said, "you must not attribute too much importance to the themes that you interpret. Without doubt, they have their value and help to charm the public; but the principal care of the artist should be to form living muscles. The rest matters little." Then, suddenly, as he guessed my confusion, he added, "You must not

think that my last words contradict what I said before.

" If I say that a sculptor can confine himself to representing palpitating flesh, without preoccupying himself with subject, this does not mean that I exclude thought from his work; if I declare that he need not seek symbols, this does not signify that I am a partisan of an art deprived of spiritual significance.

" But, to speak truly, all is idea, all is symbol. So the form and the attitude of a human being reveal the emotions of its soul. The body always expresses the spirit whose envelope it is. And for him who can see, the nude offers the richest meaning. In the majestic rhythm of the outline, a great sculptor, a Phidias, recognizes the serene harmony shed upon all nature by the divine wisdom; a simple torso, calm, balanced, radiant with strength and grace, can make him think of the all-powerful mind which governs the world.

" A lovely landscape does not appeal only by

the agreeable sensations that it inspires, but by the ideas that it awakens. The lines and the colors do not move you in themselves, but by the profound meaning that is in them. In the silhouette of trees, in the line of a horizon, the great landscape painters, Ruysdael, Cuyp, Corot, Theodore Rousseau, saw a meaning — grave or gay, brave or discouraged, peaceful or troubled — according to their characters.

" This is because the artist, full of feeling, can imagine nothing that is not endowed like himself. He suspects in nature a great consciousness like his own. There is not a living organism, not an inert object, not a cloud in the sky, not a green shoot in the meadow, which does not hold for him the secret of the great power hidden in all things.

" Look at the masterpieces of art. All this beauty comes from the thought, the intention which their creators believed they could see in the universe. Why are our Gothic cathedrals so beauti-

ful? It is because in all their presentment of life, in the human images which adorn their portals, and even in the plants which flourish in their capitals, you can discover a trace of the divine love. Those gentle craftsmen of the Middle Ages saw infinite goodness shining everywhere. And, with their charming simplicity, they have thrown reflections of this loving-kindness even on the faces of their demons, to whom they have lent a kindly malice and an air almost of relationship to the angels.

"Look at any picture by a master — a Titian, a Rembrandt, for example. In all Titian's seigneurs you notice a proud energy which, without doubt, animated himself. His opulent, nude women offer themselves to adoration, sure of their domination. His landscapes, beautified with majestic trees and crimsoned with triumphant sunsets, are not less haughty than his people: over all creation he has set a reign of aristocratic pride; it was the constant thought of his genius.

"Another kind of pride illumines the wrinkled,

167

smoke-dried face of the artisans whom Rembrandt painted; he ennobled the smoky lofts and little windows glazed with bottle ends; he illumined with sudden beauty these flat, rustic landscapes, dignified the roofs of thatch which his etching-point caressed with such pleasure on the copperplate. It was the beautiful courage of the humble, the holiness of things common but piously beloved, the grandeur of the humility which accepts and fulfils its destiny worthily, which attracted him.

" And the mind of the great artist is so active, so profound, that it shows itself in any subject. It does not even need a whole figure to express it. Take any fragment of a masterpiece, you will recognize the character of the creator in it. Compare, if you will, the hands painted in two portraits by Titian and Rembrandt. The hands by Titian will be masterful; those by Rembrandt will be modest and courageous. In these limited bits of painting all the ideals of these masters are contained."

THOUGHT IN ART

As I listened to this profession of faith in the spirituality of art an objection rose to my lips.

"Master," I said, "no one doubts that pictures and sculptures can suggest the most profound ideas; but many sceptics pretend that the painters and sculptors never had these ideas, and that it is we ourselves who put them into their works. They believe that artists work by pure instinct, like the sibyl who from her tripod rendered the oracles of God, without herself knowing what she prophesied. Your words clearly prove that your hand, at least, is ever guided by the mind, but is it so with all the masters? Have they always put thought into their work? Have they always had this clear idea of what their admirers found in them?"

"Let us understand each other," Rodin said, laughing. "There are certain admirers of such complicated brain that they attribute most unexpected intentions to the artist. We are not talking of these. But you may rest assured that the masters are always conscious of what they do." And toss-

ing his head, " If the sceptics of whom you speak
only knew what energy it takes for the artist to
translate, even feebly, what he thinks and feels
with the greatest strength, they would not doubt
that all that appears shining forth from a picture
or sculpture was intended." A few moments later
he continued: " In short, the purest masterpieces
are those in which one finds no inexpressive waste
of forms, lines, and colors, but where all, absolutely
all, expresses thought and soul.

" Yet it may happen that when the masters ani-
mate the Nature of their ideals, they delude them-
selves. It may be that it is governed by an
indifferent force or by a will whose design our in-
telligence is incapable of penetrating. At least, the
artist, in representing the universe as he imagines
it, formulates his own dreams. In nature he cele-
brates his own soul. And so he enriches the soul
of humanity. For in coloring the material world
with his spirit he reveals to his delighted fellow-
beings a thousand unsuspected shades of feeling.

He discovers to them riches in themselves until then unknown. He gives them new reasons for loving life, new inner lights to guide them.

"He is, as Dante said of Virgil, 'their guide, their master, and their friend.'"

CHAPTER IX
MYSTERY IN ART

CHAPTER IX

MYSTERY IN ART

ONE morning, when I arrived at Rodin's house at Meudon I found the master in his dressing-gown, his hair in disorder, his feet in slippers, sitting before a good wood fire, for it was November.

"It is the time of the year," he said, "when I allow myself to be ill. All the rest of the time I have so much work, so many occupations, so many cares, that I have not a single instant to breathe. But fatigue accumulates, and though I fight stubbornly to conquer it, yet towards the end of the year I am obliged to stop work for a few days."

Even as I listened to his words my eyes rested upon a great cross on the wall, on which hung the

Christ, a figure three-quarters life-size. It was a very fine painted carving of most painful realism. The body hanging from the tree looked so dead that it could never come to life — the most complete consummation of the mysterious sacrifice.

"You admire my crucifix!" Rodin said, following my glance. "It is amazing, is it not? Its realism recalls that one in the Chapel del Santisimo Christo in Burgos — that image so moving, so terrifying, yes — so horrible — that it looks like a real human corpse. This figure of the Christ is much less brutal. See how pure and harmonious are the lines of the body and arms!"

Seeing my host lost in contemplation, I ventured to ask him if he was religious.

"It is according to the meaning that you give to the word," he answered. "If you mean by religious the man who follows certain practices, who bows before certain dogmas, I am evidently not religious.

"But, to me, religion is more than the mumbling

of a creed. It is the meaning of all that is un-
explained and doubtless inexplicable in the world.
It is the adoration of the unknown force which
maintains the universal laws and which preserves
the types of all beings; it is the surmise of all
that in nature which does not fall within the
domain of sense, of all that immense realm of
things which neither the eyes of our body, nor
even those of our spirit can see; it is the impulse
of our conscience towards the infinite, towards
eternity, towards unlimited knowledge and love —
promises perhaps illusory, but which in this life
give wings to our thoughts. In this sense I am
religious." Rodin followed the rapid flickering
flames of the fire for a moment, and then con-
tinued: "If religion did not exist, I should have
had to invent it. In short, true artists are the
most religious of men.

"It is a general belief that we live only through
our senses, and that the world of appearances suf-
fices us. We are taken for children who, intoxi-

cated with changing colors, amuse themselves with
the shapes of things as with dolls. We are mis-
understood. Lines and colors are only to us the
symbols of hidden realities. Our eyes plunge be-
neath the surface to the meaning of things, and
when afterwards we reproduce the form, we endow
it with the spiritual meaning which it covers.

" An artist worthy of the name should express
all the truth of nature, not only the exterior truth,
but also, and above all, the inner truth.

" When a good sculptor models a torso, he not
only represents the muscles, but the life which ani-
mates them — more than the life, the force that
fashioned them and communicated to them, it may
be, grace or strength, or amorous charm, or in-
domitable will.

" In the works of Michael Angelo, the creative
force seems to rumble; in those of Luca della
Robbia it smiles divinely. So each sculptor, fol-
lowing his temperament, lends to nature a soul
either terrible or gentle.

MYSTERY IN ART

" The landscape painter, perhaps, goes even further. It is not only in living beings that he sees the reflection of the universal soul; it is in the trees, the bushes, the valleys, the hills. What to other men is only wood and earth appears to the great landscapist like the face of a great being. Corot saw kindness abroad in the trunks of the trees, in the grass of the fields, in the mirroring water of the lakes. But there Millet read suffering and resignation.

" Everywhere the great artist hears spirit answer to his spirit. Where, then, can you find a more religious man?

" Does not the sculptor perform his act of adoration when he perceives the majestic character of the forms that he studies? — when, from the midst of fleeting lines, he knows how to extricate the eternal type of each being? — when he seems to discern in the very breast of the divinity the immutable models on which all living creatures are moulded? Study, for example, the master-

pieces of the Egyptian sculptors, either human or animal figures, and tell me if the accentuation of the essential lines does not produce the effect of a sacred hymn. Every artist who has the gift of generalizing forms, that is to say, of accenting their logic without depriving them of their living reality, provokes the same religious emotion; for he communicates to us the thrill he himself felt before the immortal verities."

" Something," I said, " like the trembling of Faust when he visited that strange Kingdom of the Mothers, where he talked with the imperishable heroines of the great poets and beheld all the generative ideas of terrestrial realities."

" What a magnificent scene!" Rodin cried, " and what a breadth of vision Goethe had!" He continued: " Mystery is, moreover, like a kind of atmosphere which bathes the greatest works of the masters.

" They express, indeed, all that genius feels in the presence of Nature; they represent Nature

180

with all the clearness, with all the magnificence
which a human being can discover in her; but
they also fling themselves against that immense
Unknown which everywhere envelops our little
world of the known. For, after all, we only feel
and conceive those things which are patent to us
and which impress our minds and our senses.
But all the rest is plunged in infinite obscurity.
Even a thousand things which should be clear to
us are hidden because we are not organized to
seize them."

Rodin stopped, and I recalled the following lines
of Victor Hugo, which I repeated:

"Nous ne voyons jamais qu'un seul côté des choses;
 L'autre plonge en la nuit d'un mystère effrayant;
 L'homme subit l'effêt sans connaître les causes;
 Tout ce qu'il voit est court, inutile et fuyant."[1]

"The poet has put it better than I," Rodin
said, smiling, and he continued: "Great works
of art, which are the highest proof of human in-
telligence and sincerity, say all that can be said

[1] See page 251.

on man and on the world, and, besides, they teach
that there is something more that cannot be known.

"Every great work has this quality of mystery.
You always find a little 'fine frenzy.' Recall the
note of interrogation which hovers over all of
Leonardo da Vinci's pictures. But I am wrong
to choose that great mystic as an example, for he
proves my thesis too easily. Let us rather take
the *Concert Champêtre* by Giorgione. Here is all
the sweet joy of life, but added to that there is
a kind of melancholy intoxication. What is
human joy? Whence comes it? Where does it
go? The puzzle of existence!

"Again, let us take, if you will, *The Gleaners,*
by Millet. One of these women who toil so hard
beneath the blazing sun rises and looks away to
the horizon. And we feel that in that head a
question has flashed from the submerged mind:
What is the meaning of it all?

"That is the mystery that floats over all great
work. What is the meaning of the law which

chains these creatures to existence only to make them suffer? What is the meaning of this eternal enticement which makes them love life, however sad it is? Oh, agonizing problem!

"Yet it is not only the masterpieces of Christian civilization which produced this impression of mystery. It is felt before the masterpieces of antique art, before the *Three Fates* of the Parthenon, for example. I call them the Fates because it is the accepted name, though in the opinion of many students they are other goddesses; it makes little difference either way! They are only three women seated, but their pose is so serene, so august, that they seem to be taking part in something of enormous import that we do not see. Over them reigns the great mystery, the immaterial, eternal Reason whom all nature obeys, and of whom they are themselves the celestial servants.

"So, all the masters advance to the barrier which parts us from the Unknowable. Certain

among them have cruelly wounded their brows against it; others, whose imagination is more cheerful, imagine that they hear through that wall the melodious songs of the birds which people the secret orchard."

I listened attentively to my host, who was giving me his most precious thoughts on his art. It seemed that the fatigue which had condemned his body to rest before that hearth where the flames were leaping had left his spirit, on the contrary, more free, and had tempted it to fling itself passionately into dreams. I led the talk to his own works.

"Master," I said, "you speak of other artists, but you are silent about yourself. Yet you are one of those who have put into their art most mystery. The torment of the invisible and of the inexplicable is seen in even the least of your sculptures."

"Ah! my dear Gsell," he said, throwing me a glance of irony, "if I have expressed certain

184

feelings in my works, it is utterly useless for me
to try to put them into words, for I am not a
poet, but a sculptor, and they ought to be easily
read in my statues; if not, I might as well not
have experienced the feelings."

" You are right; it is for the public to discover
them. So I am going to tell you all the mystery
that I have found in your inspiration. You will
tell me if I have seen rightly. It seems to me that
what has especially interested you in humanity is that
strange uneasiness of the soul bound to the body.

" In all your statues there is the same impulse
of the spirit towards the ideal, in spite of the
weight and the cowardice of the flesh.

" In your *Saint John the Baptist*, a heavy, almost
gross body is strained, uplifted by a divine mission
which outruns all earthly limits. In your *Bourgeois
de Calais*, the soul enamoured of immortality drags
the hesitant body to its martyrdom, while it seems
to cry the words, ' Thou tremblest, vile flesh! '

" In your *Penseur*, meditation, in its terrible

effort to embrace the absolute, contracts the athletic body, bends it, crushes it. In your *Baiser*, the bodies tremble as though they felt, in advance, the impossibility of realizing that indissoluble union desired by their souls. In your *Balzac*, genius, haunted by gigantic visions, shakes the sick body, dooms it to insomnia, and condemns it to the labor of a galley-slave. Am I right, master?"

"I do not contradict you," Rodin answered, stroking his long beard thoughtfully.

"And in your busts, even more perhaps, you have shown this impatience of the spirit against the chains of matter. Almost all recall the lines of the poet:

"'Ainsi qu'en s'envolant l'oiseau courbe la branche,
 Son âme avait brisé son corps!'[1]

"You have represented all the writers with the head bent, as if beneath the weight of their thoughts. As for your artists, they gaze straight

[1] See page 251.

at nature, but they are haggard because their reverie draws them far beyond what they see, far beyond all they can express.

"That bust of a woman at the Musée du Luxembourg, perhaps the most beautiful that you have carved, bows and vacillates as if the soul were seized with giddiness upon plunging into the abyss of dreams.

"To sum it up, your busts often recall Rembrandt's portraits, for the Dutch master has also made plain this call of the infinite, by lighting the brow of his personages by a light which falls from above."

"To compare me with Rembrandt, what sacrilege!" Rodin cried quickly. "To Rembrandt, the Colossus of art! Think of it, my friend! Let us bow before Rembrandt, and never set any one beside him!

"But you have concluded justly in observing in my works the stirrings of the soul towards that kingdom, perhaps chimerical, of unlimited truth and

liberty. There, indeed, is the mystery that moves me." A moment later he asked: "Are you convinced now that art is a kind of religion?"

"Yes," I answered.

Then he added, with some malice: "It is very necessary to remember, however, that the first commandment of this religion, for those who wish to practise it, is to know how to model a torso, an arm, or a leg!"

CHAPTER X
PHIDIAS AND MICHAEL ANGELO

CHAPTER X

PHIDIAS AND MICHAEL ANGELO

ONE Saturday evening Rodin said to me, "Come and see me to-morrow morning at Meudon. We will talk of Phidias and of Michael Angelo, and I will model statuettes for you on the principles of both. In that way you will quickly grasp the essential differences of the two inspirations, or, to express it better, the opposed characteristics which divide them."

Phidias and Michael Angelo judged and commented upon by Rodin! It is easy to imagine that I was exact to the hour of our meeting.

The Master sat down before a marble table and clay was brought to him. It was winter, and as the great atelier was unheated, I was afraid that he might take cold. But the attendant to

whom I suggested this smiled as he answered, "Never, when he works."

And my disquietude vanished when I saw the fever which seized the Master when he began to knead the clay. He had asked me to sit down beside him. Rolling balls of clay on the table, he began rapidly to model a figure, talking at the same time.

"This first figure," he said, "will be founded on the conception of Phidias. When I pronounce that name I am really thinking of all Greek sculpture, which found its highest expression in the genius of Phidias."

The clay figure was taking shape. Rodin's hands came and went, adding bits of clay; gathering it in his large palms, with swift, accurate movements; then the thumb and the fingers took part, turning a leg with a single pressure, rounding a hip, sloping a shoulder, turning the head, and all with incredible swiftness, almost as if he were performing a conjuring trick. Occasionally the

PHIDIAS AND MICHAEL ANGELO

Master stopped a moment to study his work, reflected, decided, and then rapidly executed his idea.

I have never seen any one work so fast; evidently sureness of mind and eye ends by giving an ease to the hand of a great artist which can only be compared to the adroitness of a juggler, or, to make a comparison with a more honored profession, to the skill of a great surgeon. And this facility, far from excluding precision and vigor, involves them, and has, consequently, nothing whatever to do with a superficial virtuosity.

While I drew these conclusions, Rodin's statuette grew into life. It was full of rhythm, one hand on the hip, the other arm falling gracefully at her side and the head bent.

" I am not fatuous enough to believe that this quick sketch is as beautiful as an antique," the Master said, laughing, " but don't you find that it gives you a dim idea of it? "

" I could swear that it was the copy of a Greek marble," I answered.

PHIDIAS AND MICHAEL ANGELO

"Well, then, let us examine it and see from what this resemblance arises. My statuette offers, from head to feet, four planes which are alternatively opposed.

"The plane of the shoulders and chest leads towards the left shoulder — the plane of the lower half of the body leads towards the right side — the plane of the knees leads again towards the left knee, for the knee of the right leg, which is bent, comes ahead of the other — and finally, the foot of this same right leg is back of the left foot. So, I repeat, you can note four directions in my figure which produce a very gentle undulation through the whole body.

"This impression of tranquil charm is equally given by the balance of the figure. A plumb-line through the middle of the neck would fall on the inner ankle bone of the left foot, which bears all the weight of the body. The other leg, on the contrary, is free — only its toes touch the ground and so only furnish a supplementary support; it

194

could be lifted without disturbing the equilibrium. The pose is full of *abandon* and of grace.

" There is another thing to notice. The upper part of the torso leans to the side of the leg which supports the body. The left shoulder is, thus, at a lower level than the other. But, as opposed to it, the left hip, which supports the whole pose, is raised and salient. So, on this side of the body the shoulder is nearer the hip, while on the other side the right shoulder, which is raised, is separated from the right hip, which is lowered. This recalls the movement of an accordion, which closes on one side and opens on the other.

" This double balance of the shoulders and of the hips contributes still more to the calm elegance of the whole.

" Now look at my statuette in profile.

" It is bent backwards; the back is hollowed and the chest slightly expanded. In a word, the figure is convex and has the form of the letter C.

" This form helps it to catch the light, which is

distributed softly over the torso and limbs and so adds to the general charm. Now the different peculiarities which we see in this statuette may be noted in nearly all antiques. Without doubt, there are numerous variations, doubtless there are some derogations from these fundamental principles; but in the Greek works you will always find most of the characteristics which I have indicated.

" Now translate this technical system into spiritual terms; you will then recognize that antique art signifies contentment, calm, grace, balance, reason." Rodin cast a glance at his figure. " I could carry it further," he said, " but it would be only to amuse us, because, as it stands, it has sufficed me for my demonstration. The details, moreover, would add very little to it. And now, by the way, an important truth. When the planes of a figure are well placed, with decision and intelligence, all is done, so to speak; the whole effect is obtained; the refinements which come after might please the spectator, but they are almost superfluous. This

science of planes is common to all great epochs; it is almost ignored to-day."

Pushing aside the clay figure, he went on: " Now I will do you another after Michael Angelo."

He did not proceed at all in the same way as for the first. He turned the two legs of the figure to the same side and the torso to the opposite side. He bent the body forward; he folded one arm close against the body and placed the other behind the head. The attitude thus evoked offered a strange appearance of effort and of torture. Rodin had fashioned this sketch as quickly as the preceding one, only crushing his balls of clay with more vigor and putting almost frenzy into the strokes of his thumb.

" There! " he cried. " What do you think of it? "

" I should take it for a copy of a Michael Angelo — or rather for a replica of one of his works. What vigor, what tension of the muscles! "

" Now! Follow my explanation. Here, instead of four planes, you have only two; one for the

197

upper half of the statuette and the other, opposed, for the lower half. This gives at once a sense of violence and of constraint — and the result is a striking contrast to the calm of the antiques.

" Both legs are bent, and consequently the weight of the body is divided between the two instead of being borne exclusively by one. So there is no repose here, but work for both the lower limbs.

" Besides, the hip corresponding to the leg which bears the lesser weight is the one which is the more raised, which indicates that the body is pushing this way.

" Nor is the torso less animated. Instead of resting quietly, as in the antique, on the most prominent hip, it, on the contrary, raises the shoulder on the same side so as to continue the movement of the hip.

" Now note that the concentration of the effort places the two limbs one against the other, and the two arms, one against the body and the other

against the head. In this way there is no space left between the limbs and the body. You see none of those openings which, resulting from the freedom with which the arms and legs were placed, gave lightness to Greek sculpture. The art of Michael Angelo created statues all of a size, in a block. He said himself that only those statues were good which could be rolled from the top of a mountain without breaking; and in his opinion all that was broken off in such a fall was superfluous.

"His figures surely seem carved to meet this test; but it is certain that not a single antique could have stood it; the greatest works of Phidias, of Praxiteles, of Polycletus, of Scopas and of Lysippus would have reached the foot of the hill in pieces.

"And that proves how a formula which may be profoundly true for one artistic school may be false for another.

"A last important characteristic of my statuette is that it is in the form of a console; the

knees constitute the lower protuberance; the retreating chest represents the concavity, the bent head the upper jutment of the console. The torso is thus arched forward instead of backward as in antique art. It is that which produces here such deep shadows in the hollow of the chest and beneath the legs.

"To sum it up, the greatest genius of modern times has celebrated the epic of shadow, while the ancients celebrated that of light. And if we now seek the spiritual significance of the technique of Michael Angelo, as we did that of the Greeks, we shall find that his sculpture expressed restless energy, the will to act without the hope of success — in fine, the martyrdom of the creature tormented by unrealizable aspirations.

"You know that Raphael, during one period of his life, tried to imitate Michael Angelo. He did not succeed. He could not discover the secret of the condensed passion of his rival. It was because he was formed by the Greek school, as is proved

by that divine trio of the Graces at Chantilly, in which he copied an adorable antique group at Siena. Without knowing it, he constantly returned to the principles of the masters he preferred. Those of his figures in which he wished to put most strength always kept the rhythm and gracious balance of the Hellenic masterpieces.

"When I went to Italy myself, with my head full of the Greek models which I had so passionately studied at the Louvre, I found myself completely disconcerted before the Michael Angelos. They constantly contradicted all those truths which I believed that I had definitely acquired. 'Look here,' I said to myself, 'why this incurvation of the body, this raised hip, this lowered shoulder?' I was very much upset.

"And yet Michael Angelo could not have been mistaken! I had to understand. I kept at it and I succeeded.

"To tell the truth, Michael Angelo does not, as is often contended, hold a unique place in art.

He is the culmination of all Gothic thought. It is generally said that the Renaissance was the res- urrection of pagan rationalism and its victory over the mysticism of the Middle Ages. This is only half true. The Christian spirit continued to inspire a number of the artists of the Renaissance, among others, Donatello, the painter Ghirlandajo, who was the master of Michael Angelo, and Buonarotti himself.

" He is manifestly the descendant of the image-makers of the thirteenth and fourteenth centuries. You constantly find in the sculpture of the Middle Ages this form of the console to which I called your attention. There you find this same restriction of the chest, these limbs glued to the body, and this attitude of effort. There you find above all a melancholy which regards life as a transitory thing to which we must not cling."

As I thanked my host for his precious instruction, he said: " We must complete it one of these days by a visit to the Louvre. Don't forget to

remind me." At this moment a servant announced Anatole France, whom Rodin was expecting. The master sculptor had invited the great writer to come and admire his collection of antiques.

They formed a great contrast to each other. Anatole France is tall and thin. His face is long and fine; his black eyes are set deep in their sockets; his hands are delicate and slender; his gestures are vivacious and emphasize all the play of his irony. Rodin is thick-set, he has strong shoulders, his face is broad; his dreamy eyes, often half-closed, open wide at times and disclose pupils of clear blue. His beard gives him the look of one of Michael Angelo's prophets. His movements are slow and dignified. His large hands, with short fingers, are strongly supple.

The one is the personification of deep and witty analysis, the other of passion and strength.

The sculptor led us to his antiques, and the conversation naturally returned to the subject which we had just been discussing.

PHIDIAS AND MICHAEL ANGELO

A Greek stele roused the admiration of Anatole France. It represented a young woman seated. A man is gazing at her lovingly, and behind her, bending over her shoulders, stands a serving-maid.

" How the Greeks loved life! " cried the author of *Thaïs*. " See! Nothing on this funeral stone recalls death. The dead woman is here amid the living, and seems still to take part in their exist- ence. Only she has become very weak, and as she can no longer stand she must remain seated. It is one of the characteristics which designate the dead on these antique monuments: their limbs being without strength, they must lean upon a staff, or against a wall, or else sit down.

" There is also another detail which frequently distinguishes them. While the living who are figured around them all regard them with tenderness, their own eyes wander far and rest on no one. They no longer see those who see them. Yet they continue to live like beloved invalids among those who cherish them. And this half-presence, this

half-absence, is the most touching expression of the
regret which, according to the ancients, the light
of day inspired in the dead."

Rodin's collection of antiques is large and well
chosen. He is especially proud of a Hercules,
whose vigorous slimness filled us with enthusiasm.
It is a statue which does not in the least resemble
the huge Farnese *Hercules*. It is marvellously
graceful. The demi-god, in all his proud youth,
has a body and limbs of extreme slenderness.

"This is indeed," said our host, "the hero who
outran the Arcadian stag with the brazen hooves.
The heavy athlete of Lysippus would not have
been capable of such a feat of prowess. Strength
is often allied to grace, and true grace is strong;
a double truth of which this Hercules is a proof.
As you see, the son of Alcmene seems even
more robust because his body is harmoniously
proportioned."

Anatole France stopped before a charming little
torso of a goddess. "This," he said, "is one of

the numberless chaste Aphrodites which were more or less free reproductions of Praxiteles' master-piece, the *Cnidian Venus*. The *Venus of the Capitol* and the *Venus di Medici* are, among others, only variations of this much-copied model.

"Among the Greeks, many excellent sculptors spent their skill in imitating the work of some master who had preceded them. They modified the general idea but slightly, and only showed their own personality in the science of the execu-tion. It would seem, besides, that devotional zeal, becoming fond of a sculptural image, forbade artists afterwards to change it. Religion fixes once and for all the divine types that it adopts. We are astonished to find so many chaste Venuses, so many crouching Venuses. We forget that these statues were sacred. In a thousand or two thousand years they will exhume in the same way numbers of statues of the *Virgin of Lourdes,* all much alike, with a white robe, a rosary, and a blue girdle."

"What a kindly religion this of the Greeks must

have been," I cried, "which offered such charming forms to the adoration of its worshippers!"

"It was beautiful," Anatole France replied, "since it has left us these Venuses; but do not believe that it was kindly. It was intolerant and tyrannical, like all forms of pious fervor. In the name of these Aphrodites of quivering flesh many noble souls were tortured. In the name of Olympus the Athenians offered the cup of hemlock to Socrates. And do you recall that verse of Lucretius: —

'Tantum religio potuit suadere malorum!'

"You see, if the gods of antiquity are sympathetic to us to-day it is because, fallen, they can no longer harm us."

CHAPTER XI
AT THE LOUVRE

CHAPTER XI

AT THE LOUVRE

SEVERAL days later, Rodin, putting his prom-
ise into execution, asked me to accompany
him to the Musée du Louvre.

We were no sooner before the antiques than he
showed by his happy air that he was among old
friends.

"How many times," he said, "have I come here
when I was not more than fifteen years old! I had
a violent longing at first to be a painter. Color
attracted me. I often went upstairs to admire the
Titians and Rembrandts. But, alas! I had n't
enough money to buy canvases and tubes of color.
To copy the antiques, on the contrary, I needed
only paper and pencils. So I was forced to

work in the lower rooms, and there such a passion for sculpture seized me that I could think of nothing else."

As I listened to Rodin while he told of his long study of the antique, I thought of the injustice done him by those false classicists who have accused him of being an insurgent against tradition. Tradition! It is this pretended revolutionary who, in our own day, has known it best and respected it most!

He led me to the room full of casts and, pointing out the *Diadumenes* by Polycletus, the original of which is in the British Museum, he said: " You can observe here the four directions that I indicated the other day in my clay statuette. Just examine the left side of this statue: the shoulder is slightly forward, the hip is back; again the knee is forward, the foot is back; and thence a gentle undulation of the whole results.

" Now notice the balance of the levels — the level of the shoulders lower towards the right, the

level of the hips lower towards the left. Note that the plumb-line passing through the neck falls on the inner ankle bone of the right foot; note the free poise of the left leg. Finally, view in profile the convexity of the back of the statue, in form like a **C**."

Rodin repeated this demonstration with a number of other antiques. Leaving the casts, he led me to the wonderful torso of Periboëtos by Praxiteles.

" Here the direction of the shoulders is towards the left, direction of the hips towards the right — level of the right shoulder higher, level of the left hip higher." Then, passing to less theoretic impressions: " How charming! " he cried. " This young torso, without a head, seems to smile at the light and at the spring, better than eyes and lips could do." Then we reached the Venus of Milo.

" Behold the marvel of marvels! Here you find an exquisite rhythm very like that in the statue

which we have been admiring; but something of thought as well; for here we no longer find the form of the **C**; on the contrary, the body of this goddess bends slightly forward as in Christian sculpture. Yet there is nothing restless or tormented here. This work is the expression of the greatest antique inspiration; it is voluptuousness regulated by restraint; it is the joy of life cadenced, moderated by reason.

" Such masterpieces affect me strangely. They bring vividly before my mind the atmosphere and the country where they had birth. I see the young Greeks, their brown hair crowned with violets and the maidens with floating tunics as they pass to offer sacrifice to the gods in those temples whose lines were pure and majestic, whose marble had the warm transparency of flesh. I imagine the philosophers walking in the outskirts of the town, conversing upon beauty, close to some old altar which recalls to them the earthly adventure of some god. The birds sing amidst the ivy, in the

great plane-trees, in the bushes of laurel and of myrtle, and the brooks shine beneath the serene blue sky, which domes this sensuous and peaceful land."

An instant later we were before the *Victory of Samothrace.*

" Place it, in your mind, upon a golden shore, whence, beneath the olive branches, you may see the blue and shining sea cradling its white islands! Antique marbles need the full light of day. In our museums they are deadened by too heavy shadows. The reflection of the sun-bathed earth and of the Mediterranean aureoled them with dazzling splendor. Their *Victory* — it was their *Liberty* — how it differs from ours! She did not gather back her robe to leap barriers; she was clothed in fine linen, not in coarse cloth; her marvellous body in its beauty was not formed for daily tasks; her movements, though vigorous, were always harmoniously balanced.

" In truth she was the Liberty not of the whole

world, but only of the intellectually elect. The philosophers contemplated her with delight. But the conquered, the slaves who were beaten in her name, had no love for her.

"That was the fault of the Hellenic ideal. The Beauty conceived by the Greeks was the order dreamed of by intelligence, but she only appealed to the cultivated mind; she disdained the humble; she had no tenderness for the broken; she did not know that in every heart there is a ray of heaven.

"She was tyrannous to all who were not capable of high thought; she inspired Aristotle to an apology for slavery; she admitted only the perfection of form and she did not know that the expression of the most abject creature may be sublime. She destroyed the malformed children.

"But this very order which the philosophers extolled was too limited. They had imagined it according to their desires and not as it exists in the vast universe. They had arranged it according to

their human geometry. They figured the world as limited by a great crystal sphere; they feared the unlimited. They also feared progress. According to them creation had never been as beautiful as, at its birth, when nothing had yet troubled its primitive balance. Since then all had continually grown worse; each day a little more confusion had made its way into the universal order. The age of gold which we glimpse on the horizon of the future they placed behind them in the remoteness of time.

" So this passion for order betrayed them. Order reigns without doubt in the immensity of nature, but it is much more complex than man in the first efforts of his reason can represent it — and besides, it is eternally changing.

" Yet sculpture was never more radiant than when it was inspired by this narrow order. It was because that calm beauty could find entire expression in the serenity of transparent marbles; it was because there was perfect accord between the

thought and the matter that it animated. The modern spirit, on the contrary, upsets and breaks all forms in which it takes body.

" No; no artist will ever surpass Phidias — for progress exists in the world, but not in art. The greatest of sculptors who appeared at a time when the whole human dream could blossom in the pediment of a temple will remain for ever without an equal."

We passed on to the room which holds the work of Michael Angelo. To reach it we crossed that of Jean Goujon and of Germain Pilon.

" Your elder brothers," I said.

" I should like to think so," Rodin answered with a sigh. We were now before the *Captives*, by Michael Angelo. We first looked at the one on the right, which is seen in profile. " Look! only two great planes. The legs to one side, the body to the opposite side. This gives great strength to the attitude. No balance of levels. The right hip is the higher, and the right shoulder is also higher.

So the movement acquires amplitude. Observe the line of plumb — it falls not on one foot, but between the two; so both legs bear the body and seem to make an effort.

"Let us consider, finally, the general aspect. It is that of a console; the bent legs project, the retreating chest forms a hollow. It is the confirmation of what I demonstrated in my studio with the clay model."

Then, turning towards the other captive: "Here again the form of the console is designed, not by the retreating chest, but by the raised elbow, which hangs forward. As I have already told you, this particular silhouette is that of all the statuary of the Middle Ages.

"You find this form of the console in the Virgin seated leaning over her child; in the Christ nailed on the cross, the legs bent, the body bowed towards the men whom His suffering would redeem; in the Mater Dolorosa who bends above the body of her Son.

AT THE LOUVRE

"Michael Angelo, I repeat, is only the last and greatest of the Gothics.

"The soul thrown back upon itself, suffering, disgust of life, contention against the bonds of matter — such are the elements of his inspiration.

"The captives are held by bonds so weak that it seems easy to break them. But the sculptor wished to show that their bondage is, above all, a moral one. For, although he has represented in these figures the provinces conquered by Pope Julius II., he has given them a symbolic value. Each one of his prisoners is the human soul which would burst the bounds of its corporeal envelope in order to possess unlimited liberty. Look at the captive on the right. He has the face of Beethoven. Michael Angelo has divined the features of that most unhappy of great musicians.

"His whole existence proved that he was himself frightfully tortured by melancholy. 'Why do we hope for more of life and of pleasure?' he said in one of his most beautiful sonnets. 'Earthly

joy harms us even more than it delights.' And in another verse, 'He who dies soon after birth enjoys the happiest fate!'

"All his statues are so constrained by agony that they seem to wish to break themselves. They all seem ready to succumb to the pressure of despair which fills them. When Michael Angelo was old he actually broke them. Art did not content him. He wanted infinity. 'Neither painting nor sculpture,' he writes, 'can charm the soul turned towards that divine love which, upon the cross, opens its arms to receive us.' These are also the exact words of the great mystic who wrote the *Imitation of Jesus Christ:* 'The highest wisdom is to reach the kingdom of heaven through contempt of the world. It is vanity to cling to what is but passing and not to hasten towards that joy which is without end.'"

There was silence for a time, then Rodin spoke his thought: "I remember being in the Duomo at Florence and regarding with profound emotion that

Piétà by Michael Angelo. The masterpiece, which is ordinarily in shadow, was lighted at the moment by a candle in a silver candlestick. And a beautiful child, a chorister, approached the candlestick, which was as tall as himself, drew it towards him, and blew out the light. I could no longer see the marvellous sculpture. And this child appeared to figure to me the genius of Death, which puts an end to life. I have kept that precious picture in my heart."

He paused, then went on: " If I may speak of myself a little, I will tell you that I have oscillated all my life between the two great tendencies of sculpture, between the conception of Phidias and that of Michael Angelo.

" I began by following the antique, but when I went to Italy I was carried away by the great Florentine master, and my work has certainly felt the effects of this passion.

" Since then, especially more of late years, I have returned to the antique.

AT THE LOUVRE

" The favorite themes of Michael Angelo, the depths of the human soul, the sanctity of effort and of suffering, have an austere grandeur. But I do not feel his contempt of life. Earthly activity, imperfect as it may be, is still beautiful and good. Let us love life for the very effort which it exacts.

" As for me, I ceaselessly endeavor to render my outlook on nature ever more calm, more just. We should strive to attain serenity. Enough of Christian anxiety, in the face of the great mystery, will always remain in us all."

CHAPTER XII
ON THE USEFULNESS OF THE ARTIST

CHAPTER XII

ON THE USEFULNESS OF THE ARTIST

I

THE day before the *vernissage* (varnishing day), I met Auguste Rodin at the Salon de la Société Nationale in Paris. He was accompanied by two of his pupils, themselves pastmasters: the sculptor Bourdelle, who was this year exhibiting a fierce Hercules piercing the Stymphalian birds with his arrows, and Despiau, who models exquisitely clever busts.

All three had stopped before a figure of the god Pan, which Bourdelle had whimsically carved in the likeness of Rodin, and the creator of the work was excusing himself for the two small horns which he had set upon the master's forehead.

ON THE USEFULNESS OF THE ARTIST

"You had to do it," Rodin replied, laughing, "because you are representing Pan. Michael Angelo gave just such horns to his *Moses*. They are the emblem of omnipotence and omniscience, and I assure you that I am flattered to have been so favored by your attentions."

As it was now noon, Rodin invited us all three to lunch with him somewhere in the neighborhood.

We passed out into the Avenue des Champs Élysées, where beneath the crude young green of the chestnut-trees the motors and carriages slipped by in shining files, all the brilliance of Parisian life flashing here from its brightest and most fascinating setting.

"Where are we going to lunch?" Bourdelle asked, pausing with comical anxiety. "In the big restaurants about here we shall be waited upon by solemn men-servants in dress-coats, which I cannot bear. They frighten me. I advise some quiet little restaurant where the cabbies go."

"The food is really better there than in these

gorgeous places," Despiau declared. "Here the food is too sophisticated."

He had expressed Bourdelle's secret thought; for Bourdelle, in spite of his pretended modesty, is a gourmand.

Rodin agreeing, allowed them to lead him to a little eating-house hidden in a side-street off the Champs Élysées, where we chose a quiet corner and installed ourselves comfortably.

Despiau, who has a lively disposition, began teasing Bourdelle. "Help yourself, Bourdelle," he said, passing him a dish, "though you know you don't deserve to be fed, because you are an artist — that is to say, of no use to any one."

"I pardon you this impertinence," Bourdelle answered, "because you take half for yourself." He began gayly, but ended in a momentary crisis of pessimism, as he added: "But I won't contradict you. It is true that we are good for nothing. When I think of my father, who was a stone-cutter, I say to myself, 'His work was necessary

to society. He prepared the building materials for men's houses.' I can see him now, good old man, conscientiously sawing his blocks of free-stone, winter and summer, in the open workshop. His was a rugged type such as we do not see now-adays. But I — but we — what service do we render to our kind? We are jugglers, mounte-banks, dreamers, who amuse the people in the market-place. They scarcely deign to take an interest in our efforts. Few people are capable of understanding them. And I do not know whether we really deserve their good-will, for the world could very well get on without us."

II

It was Rodin who answered. " I do not believe that our friend Bourdelle means a word of what he says. As for me, my opinion is entirely opposed to his. I believe that artists are the most useful of men."

ON THE USEFULNESS OF THE ARTIST

Bourdelle laughed. "You are blinded by love of your profession."

"Not at all, for my opinion rests on very sound reasons, which I will tell you. But first have some of this wine which the *patron* recommends. It will put you in a better frame of mind to listen to me." When he had poured it out for us, he resumed: "To begin with — have you reflected that in modern society artists, I mean true artists, are about the only men who take any pleasure in their work?"

"It is certain that work is all our joy, all our life," Bourdelle cried, "but that does not mean that — "

"Wait! It seems to me that what is most lacking in our contemporaries is love of their profession. They only accomplish their tasks grudgingly. They would willingly *strike*. It is so from the top to the bottom of the social ladder. The politician sees in his office only the material advantages which he can gain from it, and he does not seem to know

the pride which the old statesmen felt in the skilful direction of the affairs of their country.

"The manufacturer, instead of upholding the honor of his brand, strives only to make as much money as he can by adulterating his products. The workman, feeling a more or less legitimate hostility for his employer, slights his work. Almost all the men of our day seem to regard work as a frightful necessity, as a cursed drudgery, while it ought to be considered as our happiness and our excuse for living.

"You must not think that it has always been so. Most of the objects which remain to us from the old days, furniture, utensils, stuffs, show a great conscientiousness in those who made them.

"Man likes to work well, quite as much as to work badly. I even believe that it is more agreeable to him, more natural to him, that he *prefers* to work well. But he listens sometimes to good, sometimes to bad advice, and gives preference to the bad.

ON THE USEFULNESS OF THE ARTIST

"And yet, how much happier humanity would be if work, instead of a means to existence, were its end! But, in order that this marvellous change may come about, all mankind must follow the example of the artist, or, better yet, become artists themselves; for the word *artist,* in its widest acceptation, means to me the *man who takes pleasure in what he does.* So it would be desirable were there artists in all trades — artist carpenters, happy in skilfully raising beam and mortice — artist masons, spreading the plaster with pleasure — artist carters, proud of caring for their horses and of not running over those in the street. Is it not true that that would constitute an admirable society?

"You see, then, that artists set an example to the rest of the world which might be marvellously fruitful."

"Well argued," cried Despiau; "I take back what I said, Bourdelle. I acknowledge that you deserve your food. Do take a little more asparagus."

ON THE USEFULNESS OF THE ARTIST

III

" Ah, Master! " I said, " you doubtless have the gift of persuasion. But, after all, what is the good of proving the usefulness of artists? Certainly, as you have shown us, their passion for work might set a good example. But is not the work which they do at the bottom useless, and is it not that precisely which gives it value in our eyes? "

" What do you mean? "

" I mean, that happily works of art do not count among useful things, that is to say, amongst those that serve to feed us, to clothe us, to shelter us — in a word, to satisfy our bodily needs. On the contrary, they tear us from the slavery of practical life and open before us an enchanted land of contemplation and of dreams."

" The point is, my dear friend, that we are usually mistaken in what is useful and what is not," Rodin answered. " I admit that we must call useful all that ministers to the necessities of

our material life. But to-day, besides that, riches are also considered useful, though their display only arouses vanity and excites envy; these riches are not only useless, but cumbersome.

" As for me, I call *useful all that gives us happiness*. Well, there is nothing in the world that makes us happier than contemplation and dreams. We forget this too much in our day. The man who, with just a sufficiency, wisely enjoys the numberless wonders which meet his eyes and mind at every turn — who rejoices in the beauty and vigor of the youth about him; who sees in the animals, those wonderful living machines, all their supple and nervous movements and the play of their muscles; who finds delight in the valleys and upon the hillsides where the spring spends itself in green and flowery festival, in waves of incense, in the murmur of bees, in rustling wings and songs of love; who feels an ecstasy as he watches the silver ripples, which seem to smile as they chase each other upon the surface of the water;

who can, with renewed enthusiasm, each day watch Apollo, the golden god, disperse the clouds which Earth wraps closely around her; the man who can find joy in all this walks the earth a god.

"What mortal is more fortunate than he? And since it is art which teaches us, which aids us to appreciate these pleasures, who will deny that it is infinitely useful to us? It is not only a question of intellectual pleasures, however, but of much more. Art shows man his *raison d'être*. It reveals to him the meaning of life, it enlightens him upon his destiny, and consequently points him on his way. When Titian painted that marvellously aristocratic society, where each person carries written in his face, imprinted in his gestures and noted in his costume, the pride of intellect, of authority and of wealth, he set before the patricians of Venice the ideal which they wished to realize. When Poussin composed his clear, majestic, orderly landscapes, where Reason seems to reign; when Puget swelled the muscles of his heroes;

when Watteau sheltered his charming yet melancholy lovers beneath mysterious shades; when Houdon caused Voltaire to smile, and Diana, the huntress, to run so lightly; when Rude, in carving the *Marseillaise*, called old men and children to his country's aid — these great French masters polished in turn some of the facets of our national soul; this one, order; this one, energy; this one, elegance; this one, wit; this one, heroism; and all, the joy of life and of free action, and they kept alive in their compatriots the distinctive qualities of our race.

" Take the greatest artist of our time, Puvis de Chavannes — did he not strive to shed upon us the serenity to which we all aspire? Are there not wonderful lessons for us in his sublime landscapes, where holy Nature seems to cradle upon her bosom a loving, wise, august, simple humanity? Help for the weak, love of work, self-denial, respect for high thought, this incomparable genius has expressed it all! It is a marvellous light upon our

epoch. It is enough to look upon one of his masterpieces, his *Sainte Geneviève* in the Panthéon, his *Holy Wood* (*Bois Sacré*) in the Sorbonne, or his magnificent *Homage to Victor Hugo* (*Hommage à Victor Hugo*) on the stairway of the Hôtel de Ville in Paris, to feel oneself capable of noble deeds.

"Artists and thinkers are like lyres, infinitely delicate and sonorous, whose vibrations, awakened by the circumstances of each epoch, are prolonged to the ears of all other mortals.

"Without doubt, very fine works of art are appreciated only by a limited number; and even in galleries and public squares they are looked at only by a few. But, nevertheless, the thoughts they embody end by filtering through to the crowd. Below the men of genius there are other artists of less scope, who borrow and popularize the conceptions of the masters: writers are influenced by painters, painters by writers; there is a continual exchange of thought between all the brains of a

generation — the journalists, the popular novelists, the illustrators, the makers of pictures bring within the reach of the multitude the truths discovered by the powerful intellects of the day. It is like a spiritual stream, like a spring pouring forth in many cascades, which finally meet to form the great moving river which represents the mentality of an era.

" And it should not be said, as it is sometimes, that artists only reflect the feeling of their surroundings. Even this would be much; for it is well to hold up a mirror in which other men may see themselves, and so to aid them to self-knowledge. But artists do more. Certainly they draw largely from the common fund amassed by tradition, but they also increase this treasure. They are truly inventors and guides.

" In order to convince oneself of this, it is enough to observe that most of the masters preceded, and sometimes by a long period, the time when their works won recognition. Poussin painted a number

of masterpieces under Louis XIII. whose regular
nobility foretold the character of the following
reign; Watteau, whose nonchalant grace would
seem to have presided over all the reign of Louis
XV., did not live under that King, but under
Louis XIV., and died under the Regent; Chardin
and Greuze, who, in celebrating the bourgeois
home, would seem to have announced a democratic
society, lived under a monarchy; Prudhon, mysti-
cal, sweet and weary, claimed, in the midst of
strident imperial fanfares, the right to love, to
meditate, to dream, and he affirmed it as the
forerunner of the romantics. Nearer to us, Cour-
bet and Millet, under the Second Empire, pictured
the sorrows and the dignity of the people, who
since then, under the Third Republic, have won
so preponderant a place in society.

"I do not say that these artists determined these
great currents, I only say that they unconsciously
contributed to form them; I say that they made
part of the intellectual élite who created these ten-

dencies. And it goes without saying that this élite is not composed of artists only, but also of writers, philosophers, novelists and publicists.

"What still further proves that the masters bring new ideas and tendencies to their generations is that they have often great trouble in winning acknowledgment for them. They sometimes pass nearly all their lives in striving against routine. And the more genius they have, the more chance they run of being long misunderstood. Corot, Courbet, Millet, Puvis de Chavannes, to cite no more, were not unanimously acclaimed until the end of their careers.

"It is impossible to do good to mankind with impunity. But, at least, the masters of art, by their determination to enrich the human soul, have deserved that their names should be held sacred after their deaths.

"There, my friends, is what I wished to say to you upon the usefulness of artists."

IV

I declared that I was convinced.

"I only want to be," said Bourdelle, "for I adore my work, and my grumbling was doubtless the effect of a passing mood; or, perhaps, anxious to hear an apology for my profession, I behaved like a coquette who complains of being ugly in order to provoke a compliment."

There was silence for several instants, for we were thinking of what had been said.

Then, realizing that Rodin had modestly omitted himself in indicating the influence of the masters, I said: "Master, you have yourself exercised an influence on your epoch, which will certainly be prolonged to succeeding generations.

"In emphasizing so strongly the inner truth, you will have aided in the evolution of our modern life. You have shown the immense value which each one of us to-day attaches to his thoughts, to his affections, to his dreams, and often to his wan-

dering passions. You have recorded the intoxication of love, maiden reveries, the madness of desire, the ecstasy of meditation, the transports of hope, the crises of dejection. You have ceaselessly explored the mysterious domain of the individual conscience, and you have found it ever more vast. You have observed that in this era upon which we have entered, nothing has more importance for us than our own feelings, our own intimate personality. You have seen that each one of us, the man of thought, the man of action, the mother, the young girl, the lover, places the centre of the universe in his own soul. And this disposition, of which we were ourselves almost unconscious, you have revealed to us.

"Following upon Victor Hugo, who, celebrating in his poetry the joys and the sorrows of private existence, sang the mother rocking the cradle, the father at the grave of his child, the lover absorbed in happy memories, you have expressed in sculpture the deepest, most secret emotions of the soul.

ON THE USEFULNESS OF THE ARTIST

"And there is no doubt but that this powerful wave of individualism which is passing over the old society will modify it little by little. There is no doubt but that, thanks to the efforts of the great artists and the great thinkers, who ask each one of us to consider himself as an end sufficient unto himself, and to live according to the dictates of his own heart, humanity will end by sweeping aside all the tyrannies which still oppress the individual and will suppress the social inequalities which subject one to another, the poor to the rich, the woman to the man, the weak to the strong.

"You, yourself, by the sincerity of your art, will have worked towards the coming of this new order."

But Rodin answered with a smile:

"Your great friendship accords me too large a place among the champions of modern thought. It is true, at least, that I have striven to be of use by formulating as clearly as I could my vision of people and of things."

ON THE USEFULNESS OF THE ARTIST

In a moment he went on:

" If I have insisted on our usefulness, and if I still insist upon it, it is because this consideration alone can recall to us the sympathy which is our due in the world in which we are living. To-day, every one is engrossed by self-interest; but I would like to see this practical society convinced that it is at least as much to its advantage to honor the artist as to honor the manufacturer and the engineer."

TRANSLATIONS

TRANSLATIONS

Page 37

Ah! proud and traitorous old age!

Why have you so soon brought me low? Why do you hold me so that I cannot strike and with the stroke end my sorrow?

Pages 38 and 39

When I think wearily on what I was, of what I am, when I see how changed I am — poor, dried-up, thin — I am enraged! Where is my white forehead — my golden hair — my beautiful shoulders, all in me made for love? This is the end of human beauty! These short arms, these thin hands, these humped shoulders. These breasts —

these hips — these limbs — dried and speckled as sausages!

Pages 44 and 45

Yet one day you will be like this — like this horrible contamination — thou star of my eyes, thou sun of my nature, oh my angel and my passion! Yes, such will you be, oh Queen of the Graces, after the last sacraments — when you are laid under the grass and the flowers, there to crumble among the bones. Then oh, my beautiful one! tell the worms, when they devour you with kisses, that in spite of them, in spite of all, I have kept the form and the divine essence of my love who has perished.

Page 118

Flesh of the woman, ideal clay; oh sublime penetration of the spirit in the slime; matter, where the soul shines through its shroud; clay, where one sees the fingers of the divine sculptor; august

dust, which draws kisses, and the heart of man; so holy that one does not know — so entirely is love the conqueror, so entirely is the soul drawn — whether this passion is not a divine thought; so holy that one cannot, in the hour when the senses are on fire, hold beauty without embracing God!

Page 181

We never see but one side of things — the other is plunged in night and mystery. Man suffers the effect without knowing the cause. All that he sees is short, useless, and fleeting.

Page 186

As when, in taking flight, the bird bends the branch, so his soul had bruised his body.

INDEX

INDEX

255

INDEX

INDEX

INDEX

INDEX